PAST & PRESENT

NEW ORLEANS

Opposite: Shown here is the quintessential French Quarter photograph, with almost all the elements it is known for present in a single frame: wrought iron balconies, historic drinking establishments, and a streetcar named Desire. (Past image, The Historic New Orleans Collection/Elmer C. Freed; present image, author's collection.)

PAST & PRESENT

NEW ORLEANS

Troy Broussard

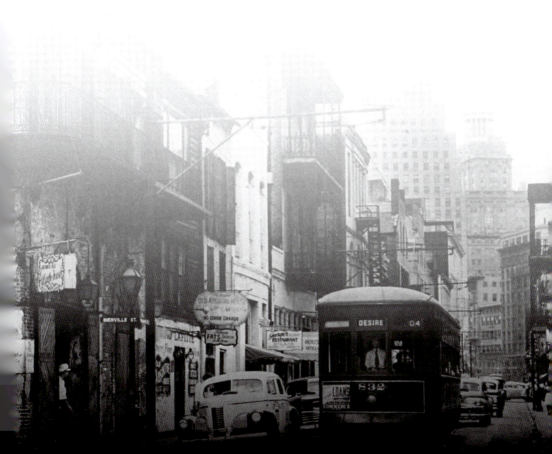

For Deslie—my today and my tomorrow.

Copyright © 2024 by Troy Broussard
ISBN 978-1-4671-6123-7

Library of Congress Control Number: 2023947591

Published by Arcadia Publishing
Charleston, South Carolina

Printed in the United States of America

For all general information, please contact Arcadia Publishing:
Telephone 843-853-2070
Fax 843-853-0044
E-mail sales@arcadiapublishing.com

Visit us on the Internet at www.arcadiapublishing.com

ON THE FRONT COVER: After living under the flags of foreign nations, Louisiana joined the US Union by virtue of the 1803 Louisiana Purchase, which was formally finalized on the site of what would be renamed Jackson Square following the Battle of New Orleans in 1815. Today, Clark Mills's sculpture of Pres. Andrew Jackson, astride his steed, in front of the three spires of St. Louis Cathedral, is almost the virtual visual trademark of the "Crescent City" recognized around the world. (Past image, Library of Congress; present image, photograph by Troy Broussard.)

ON THE BACK COVER: The downtown segment of St. Charles Avenue has consistently served as a bustling corridor for both business and leisure from the formation of the business district through the modern era. Here, the world-famous street is shown in the early 1900s. (Past image, Library of Congress.)

Contents

Acknowledgments		vii
Introduction		ix
1.	The Old New Orleans	11
2.	Down by the River	25
3.	St. Charles Avenue	39
4.	The Business District	47
5.	NOLA's Neighborhood Flavor	61
6.	Mardi Gras Memories	91

Acknowledgments

I would like to acknowledge the invaluable assistance of Robert Ticknor at The Historic New Orleans Collection (THNOC) as well as the gifts of contributors to the special collections used in this book. Thank you to Tulane University (Michael Strecker, Susan McCann, and Michael Moorse); the Audubon Nature Institute (Heather Stanley), the University of New Orleans (Adam Norris); Loyola University of New Orleans (Jeanine Smith and Andrew Lau); the State Library of Louisiana (Charlene Bonnette); New Orleans Public Library City Archives & Special Collections (Erin Patterson); the New Orleans Jazz Club Collection of the Louisiana State Museum/New Orleans Jazz Museum; the New Orleans Public Library (Christina Bryant and Amanda Fallis); and Boh Brothers Construction Co., LLC (Kyle Crabtree). I would also like to thank the staff at our nation's largest national historical repository, the Library of Congress (LOC), and the creators of works now in the public domain (PD).

The people in my life who made me a student of history by sharing their own experiences through time deserve my gratitude as well. To that end, I recognize (among many others) my grandmother Anna; my parents, Pat and Aaron; my Aunt Betty; my father-in-law, Les Bonano; and my mentor, Carl Mullican.

Last, but not least, thank you to the team at Arcadia Publishing, including editor Caroline (Anderson) Vickerson and Lindsey Givens, for your encouragement and expertise.

Unless otherwise noted, all present-day images were taken by the author.

INTRODUCTION

Civilizations pride themselves on change. "Progress" is equated with taller buildings, modern infrastructure, and all things "new." While the name of the city "New Orleans" itself implies reinvention, among the details most beloved by residents and visitors alike in the 21st century are the things that have not changed here very much over time. From the top of a levee, you can still see paddle wheelers churning water on the Mississippi. Our restaurants have served as the backdrop for generations of family meals, often prepared and delivered by staff who have worked there for decades themselves. The same wrought iron balconies that drew the eyes of tourists in the 1920s, still do in the 2020s. The Mardi Gras experience continues to captivate participants from all corners of the planet every year, along sacrosanct parade routes. These aspects of daily life are icons that represent New Orleans to the rest of the world.

There is an inherent challenge in compiling a "then and now" comparison of locations within a city that has existed for over three centuries: where does one start and stop? A locale such as the riverfront, for example, displayed drastically different looks through its eras, as it went from a simple colonial port to a regional economic engine, then from a rundown memory of old warehouses to a revitalized arts and entertainment district. Aside from tracing the natural crescent of the waterway it adjoins, a part of New Orleans could be unrecognizable in the time it takes for a child to become a parent to his or her own children. But it is during that precise transition that the knowledge of what "was" gets passed down as a cherished gift. I remember listening at the feet of older family members about places in the past that were so important to the people remembering them, that the recollections were a visceral mix of painful loss and loving nostalgia. I never got the chance to sit in the stands of the old Tulane Stadium before it was demolished but know those who had some of the best times in their lives watching games there. To this thread, for my own children and grandchildren, I add that as a boy I watched the same team play (and lose often) in the Superdome.

For better or worse, New Orleans is a place that has been rebuilt more times than it has been renovated. Since its beginning, the "Crescent City" has stubbornly existed despite great odds. Below sea level and in the strike zone for storms that claw across the Gulf of Mexico, nature has played a prominent role in shaping the destiny of the metropolitan area. The history of New Orleans, as recorded by its buildings and topography, is one of a cycle that pits tragedy against rebirth. Although many may recall the devastation imposed by Hurricane Katrina in 2005, it was far from being the first natural disaster endured by NOLA residents. Fires and floods have destroyed infrastructure since the French first set foot here. All of this is to say that when this community rebuilds, it does so with the spirit of "we've been here before, and we'll be all right again, y'all." You cannot tell the story of this city without understanding its people. We have a determination to not only survive, but also celebrate life while pressing ahead. To stand up after being knocked down. To put a tarp over what's left of your house and brag to your neighbor

about your fancy new "Blue Roof." It is in a New Orleanian's nature to roll up their sleeves and put in the work when most would have called it quits. That is either true love or insanity—maybe both.

In researching this book, I had the opportunity to confront and discredit my personal biases. Maybe it is common to look back on the past from a modern perch and think that your forebearers were quaint or lacked sophistication. If I ever did, then I no longer do. It was quite the experience when I came across a book from 1905 whose purpose was to point out differences between the turn-of-the-century and "old" New Orleans. It gave me some perspective on how long those who appreciate the city have tried to capture its changing beauty and nuances over the years. Preservation was a common theme in the material I looked at. Stories in print about people who showed up to mourn a part of the city being torn down or lost, while protesting the replacements. For me, a great debt is owed to those who served as link in the chain between then and now. To the forward-thinking individuals who went out into the city streets and neighborhoods with cameras and sketchbooks to record life at that moment before it all changed. And the countless nameless others who diligently organized those moments into archives and collections so that we may appreciate the past. But for them, how much of our story and collective memory would have been lost forever?

A second assumption of mine that went by the wayside was that those who lived in the past existed differently somehow and, perhaps better, in the proverbial "good old days." Simpler times with fewer problems to contend with. But that just is not true. Where, in one century, the city contended with the COVID pandemic, a former one dealt with the Spanish flu. Political and social debates over issues sparked as much passion on both sides as what is experienced today. We fear the threat of war when, in the 1940s, thousands of New Orleanians worked around the clock at Higgins Industries to build the boats that our nation's soldiers used to victoriously storm the beaches of Normandy, while the world's future hung in the balance. We watch the ups and downs of inflation when millions of people survived a complete national economic collapse not a century ago.

The cars and clothing may look different, and a building in a particular location may have been replaced, but at the end of the day, we have a lot more in common with those folks in the black-and-white photographs than you might think. Their work, struggles, achievements, and even mistakes have paved the road that has brought us to this moment. (I just wish they had filled in a few of those uptown potholes along the way.) Some things should be remembered for how good they were, and some things should be remembered for how bad they were so that we do not repeat the same mistakes in the future.

This, at last, brings me to another group of individuals, past and present, who deserve recognition as well: those who are constantly imagining new ways to rejuvenate the city. Whether it is by changing the skyline of the Central Business District or opening a corner restaurant. One of the beautiful facets of New Orleans is how it can warmly welcome new people, places, and traditions with open arms and easily incorporate them into the existing fabric of the city.

It is my hope that this book will inspire you to take your spot in the city's never-ending second-line celebration of life.

CHAPTER 1

THE OLD NEW ORLEANS

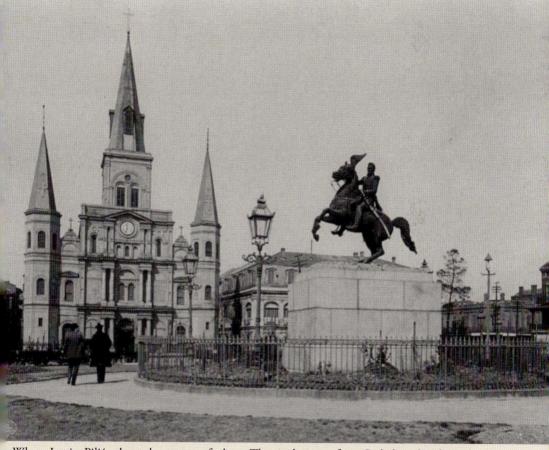

When Louis Pilié planned aspects of the Louisiana colony, he found inspiration in the city squares of Paris. The result, initially called the Place d'Armes, was a multipurpose space for activities that ranged from military drills to a market for farmers and artisans. The inclusion of a Catholic church and the governor's residence, combined with a proximity to the port on the Mississippi River, gave the location added importance. Today, Jackson Square is the city's most iconic image. (Past image, LOC.)

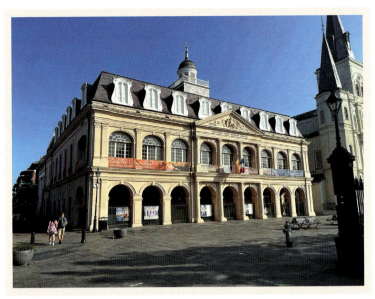

After burning in the Great New Orleans Fire of 1788, the Cabildo was rebuilt by 1795. The building's name itself reflects its use by the Spanish government, roughly translated into "city council." In 1803, the building hosted the Louisiana Purchase transfer ceremony. The main hall was later used by the Louisiana Supreme Court and became a Louisiana State Museum in 1911. After fire again damaged the building in 1988, a painstaking restoration of the structure was completed in 1994. (Past image, LOC.)

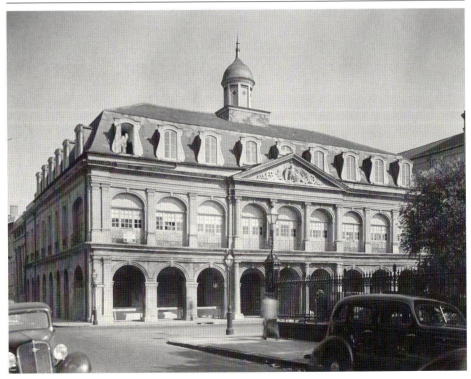

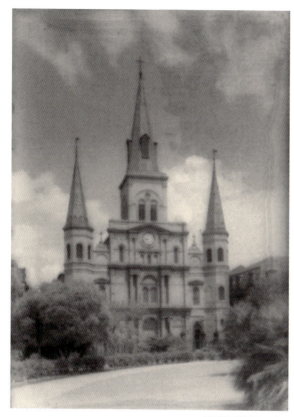

The three-spired St. Louis Cathedral, named after the King of France and Catholic Saint Louis IX, has served as a place of worship for New Orleanians since 1727. The original cathedral was destroyed in the Great New Orleans Fire of 1788 and has been the object of perpetual restoration and preservation through the present age. (Past image, a gift of Joel Jergins and Eugene Delcroix, THNOC, the New Orleans Museum of Art.)

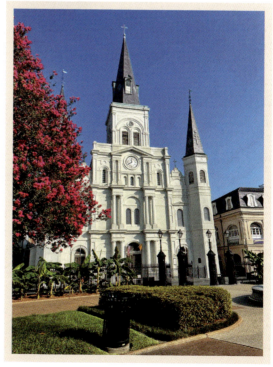

THE OLD NEW ORLEANS

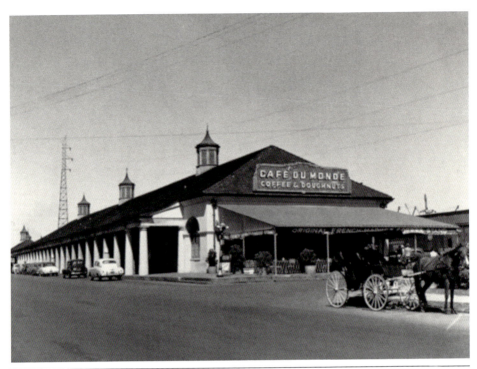

Translated from French as the "Café of the world," this Decatur Street coffee shop is known for its signature beignets, which are made from squared dough and covered with powdered sugar. Its chicory-blended black coffee is also a local favorite, whether served straight or "au lait," meaning "with milk." Café du Monde has operated from the same location across from Jackson Square, at the end of the French Market, since 1862. (Past image, the Richard R. Dixon/Cole Coleman Collection, Mr. and Mrs. Richard R. Dixon, THNOC.)

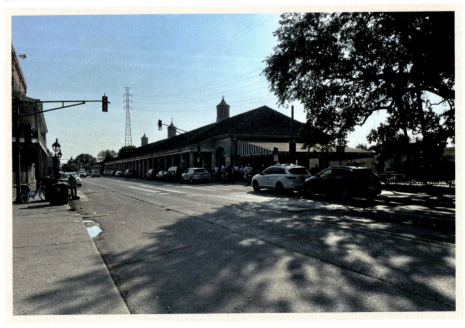

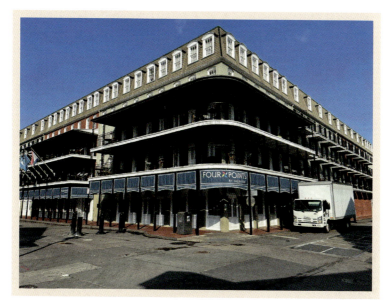

As a European colony, it is no wonder that New Orleans embraced the arts early in its history and became the first United States city to host an opera company. This appreciation manifested itself in the completion of the French Opera House on the corner of Bourbon and Toulouse Streets in 1859. The Greek Revival–style exterior enclosed four levels of seating around a proscenium stage. A fire destroyed the building in 1919. (Past image, Mr. and Mrs. Elvert M. Cormack, THNOC.)

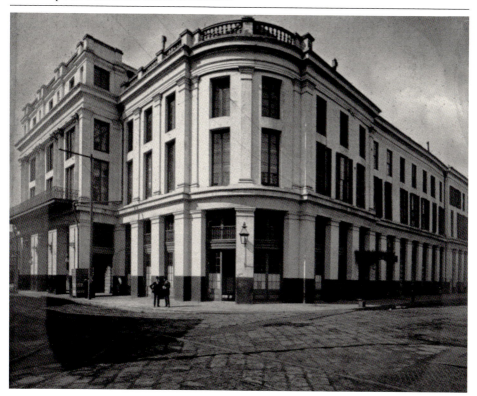

THE OLD NEW ORLEANS

After almost 200 years, the LaLaurie House still figures prominently in the "supernatural" landscape of the city. After an 1834 fire revealed the atrocities of socialite Delphine (MacCarthy) LaLaurie against slaves, thousands of residents reportedly gathered to destroy what was left of the mansion and chase the LaLaurie family from town. Though a new structure would be built in its place, the address on Royal Street has never been able to shake its "haunted" reputation. (Past image, LOC.)

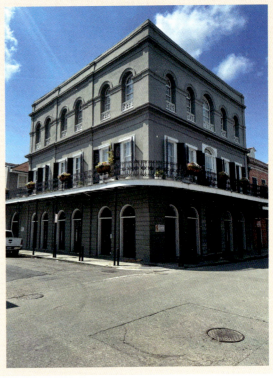

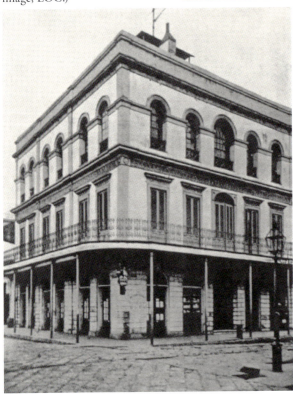

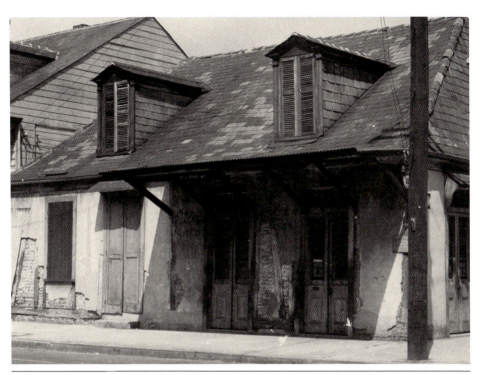

Even among local historians, opinions vary on exactly when, in the 18th century, this Creole-style cottage on the corner of Bourbon and St. Phillip Streets was built. It is rumored, however, that local privateers Jean and Pierre Lafitte used it as a front for their smuggling operations. Now a popular bar, owners of Lafitte's Blacksmith Shop lay claim to the distinction of having the oldest building, which houses a drinking establishment, within the United States. (Past image, LOC; present image, photograph by Beth Williamson.)

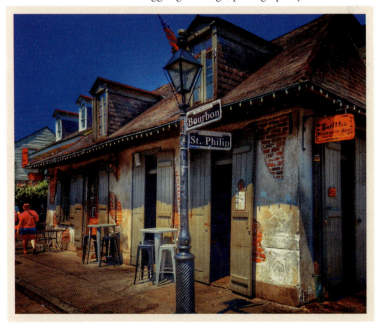

Napoleon Bonaparte never lived here, although local lore says that the house was originally constructed for the exiled French emperor. Officially, the highest-ranking politico to ever reside at the corner of St. Louis and Chartres Streets was New Orleans mayor Nicholas Girod. In the 20th century, this landmark became Napoleon Café and Grocery, before its present incarnation of the Napoleon House, one of the city's favorite drinking establishments. (Past image, LOC; present image, photograph by Beth Williamson.)

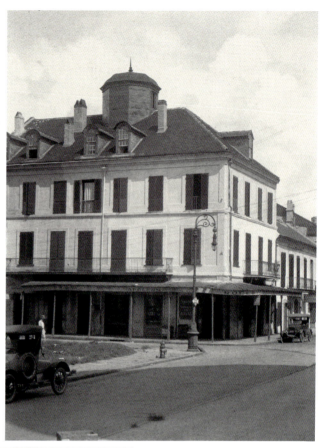

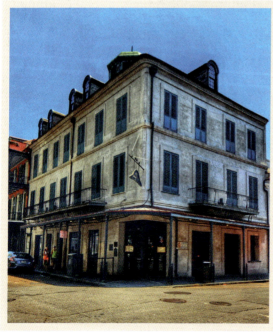

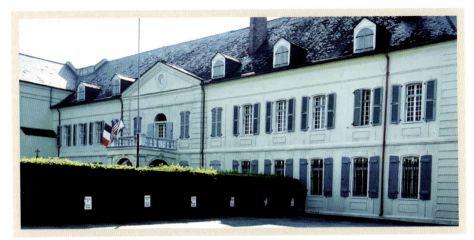

Although the Ursuline nuns traveled from France to the Louisiana colony in the 1720s, the first building to house them reportedly was not completed until 1734. Reconstructed from stucco brick in 1753, the Ursuline Convent originally faced the Mississippi River on Chartres Street. The Sisters relocated to a new home in 1824, and today, their former residence is considered to be one of the finest surviving examples of French Colonial public architecture in the United States. (Past image, THNOC.)

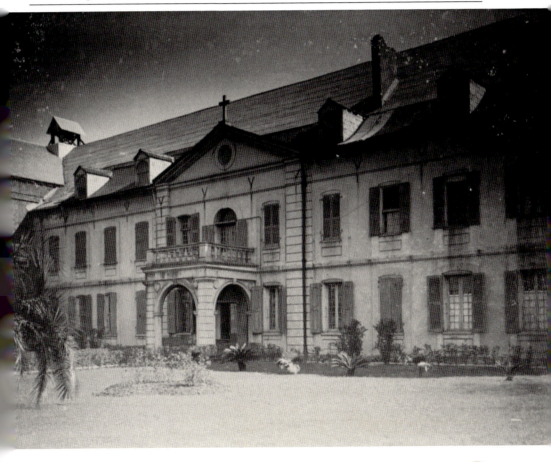

THE OLD NEW ORLEANS

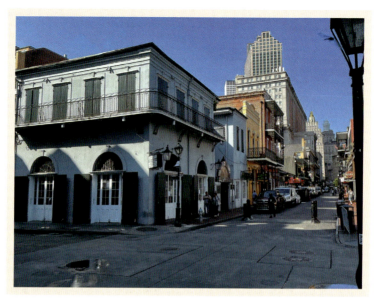

Originally named Rue Bourbon by one of the city's developers in honor of the royal French family and changed to Calle de Borbón under Spanish rule, these famous city blocks became "Bourbon Street" after the Louisiana Purchase. Largely considered to be a residential area prior to the start of the 20th century, after World War II it evolved into the venue for bars and burlesque shows that it is still known for today. (Past image, Elmer C. Freed, THNOC.)

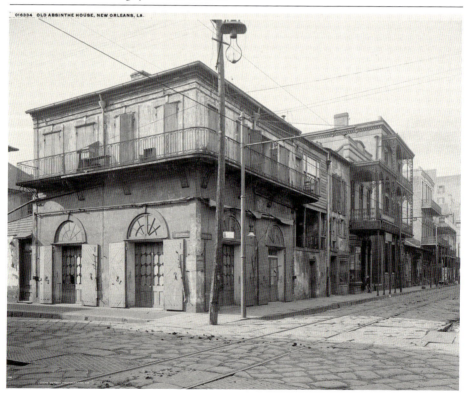

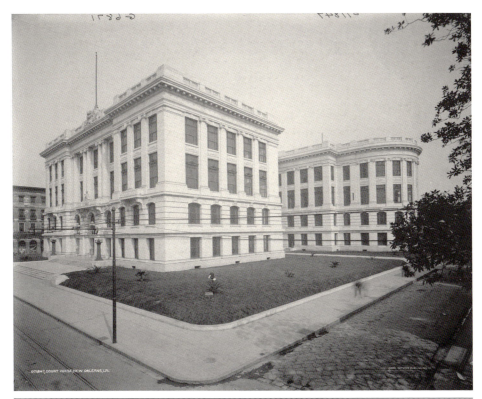

The Beaux-Arts–style building on Royal Street originally became a home for the Louisiana Supreme Court upon completion in 1910. Though it remained abandoned after the court moved to the Civic Center Complex on Loyola Avenue in 1958, the solidly built granite and marble structure would later undergo a lengthy renovation process, which culminated with the court's 2004 return. Today, the building also houses the Louisiana Fourth Circuit Court of Appeal. (Past image, LOC.)

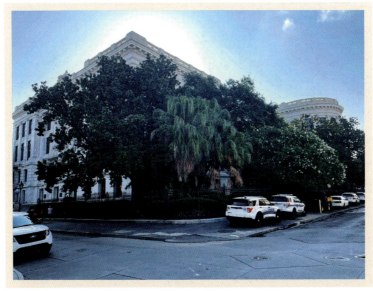

THE OLD NEW ORLEANS 21

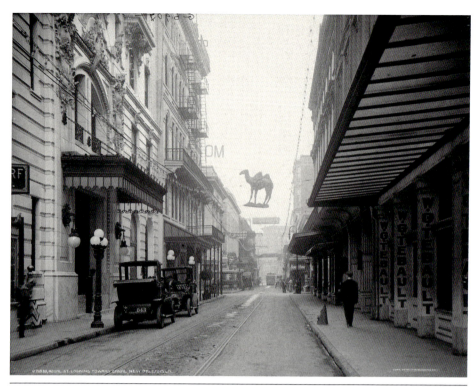

One of the original 18th-century streets in New Orleans, Rue Royale, or Calle Real, has historically served as an important commercial corridor in the city. Stretching from the French Quarter to Jackson Barracks, Royal Street is known today as an area for high-end stores offering art and antiques. The street is also pedestrian and street-performer-friendly at times between St. Louis and St. Ann Streets, with those blocks regularly closed to traffic. (Past image, LOC.)

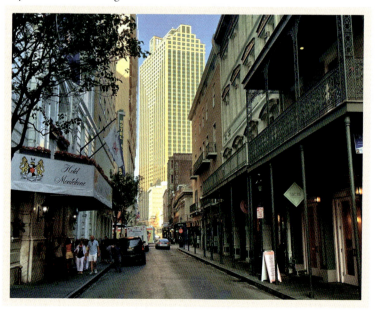

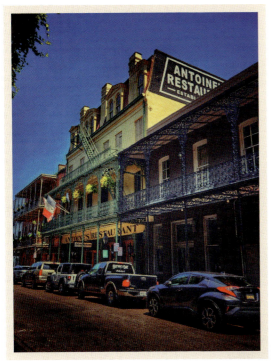

With the distinction of being the oldest restaurant in New Orleans, the location at 713 St. Louis Street is also in equal part a beloved venue where generations have celebrated occasions in its 15 dining rooms. True to its Creole roots, Antoine's menu still features the original names of its dishes alongside English translations. US presidents and a pope are among those who have enjoyed its cuisine and perhaps a selection from its legendary wine cellar. (Past image, State Library of Louisiana; present image, photograph by Beth Williamson.)

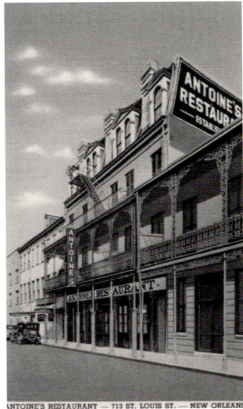

THE OLD NEW ORLEANS

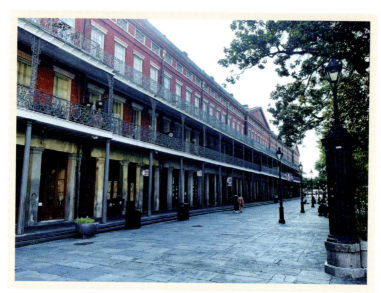

Commonly called "the Pontalba," these block-long architectural bookends to Jackson Square were completed in 1851 by Baroness Micaela Almonester Pontalba. Today, the buildings house businesses on the first floor with apartments on the levels above. Of note, the Pontalba buildings are considered to be the first in New Orleans to incorporate cast-iron galleries, which later became an architectural signature of many French Quarter balconies. (Past image, the Richard R. Dixon/Cole Coleman Collection, Mr. and Mrs. Richard R. Dixon, THNOC.)

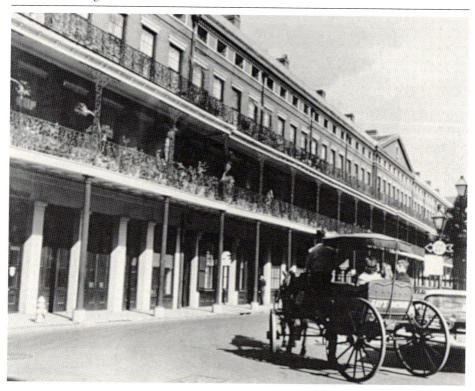

24 THE OLD NEW ORLEANS

CHAPTER

Down by the River

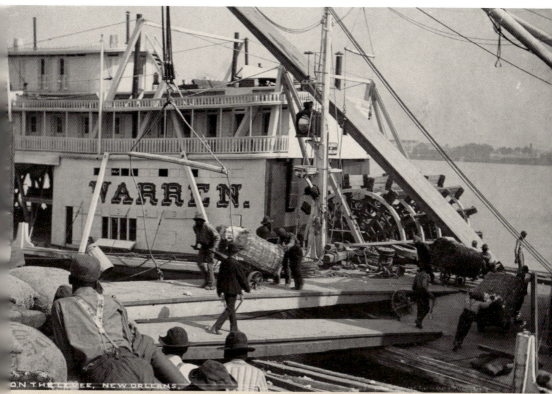

A familiar sight since Robert Fulton's aptly named steamboat *New Orleans* made it downriver in 1812, these mechanical marvels made trade possible from the local port to upriver destinations with cargo such as coffee and sugar. (Past image, LOC.)

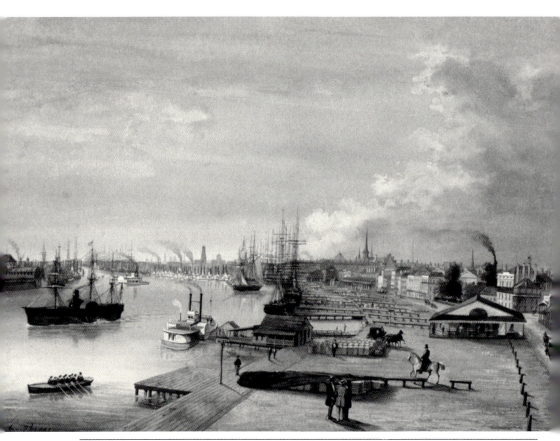

New Orleans has always been an international port city. Its unique position as the gateway to the Mississippi was perhaps best demonstrated by the Union early in the Civil War when it captured and restricted access to stop Confederate supply lines. Today, it is estimated the deepwater port generates $100 million annually through its traditional business of cargo and rail and its more modern functions as a cruise terminal and real estate holder. (Past image, acquisition made possible by the Clarisse Claiborne Grima Fund, the William Russell Jazz Collection at the Historic New Orleans Collection, THNOC; present image, Jovannig/Adobe Stock.)

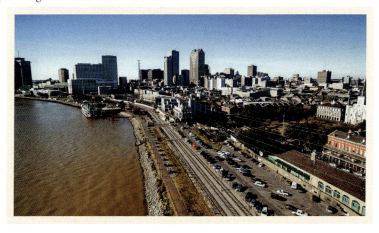

While not considered an economic success, the 1984 Louisiana World Exposition was perhaps one of the greatest precursors for riverfront redevelopment in the city's history. With the theme of "The World of Rivers—Fresh Waters as a Source of Life" and a pelican mascot named Seymore D. Fair, a former rail yard on the outskirts of the Central Business District transformed into a showcase for both international and local culture. (Past image, Christopher Porche West, THNOC.)

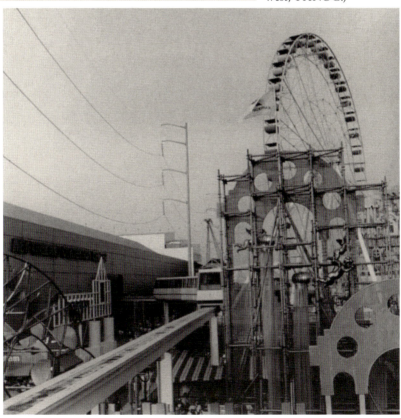

Down by the River

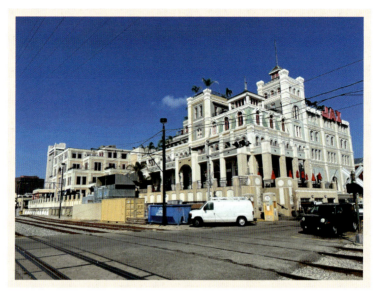

The Jax brand, named as a tribute to Andrew Jackson and his nearby square, originated as the Jackson Bohemian Brewery in the 1890s. Producing hundreds of thousands of barrels per day at its peak before Prohibition, the beer company closed its riverfront building in 1974. An example of reinvestment of the city's waterfront while also preserving the city's local character, Jax Brewery opened in 1984 as the site of shopping, dining, and, more recently, residences. (Past image, Judy Rabouin Tarantino, THNOC.)

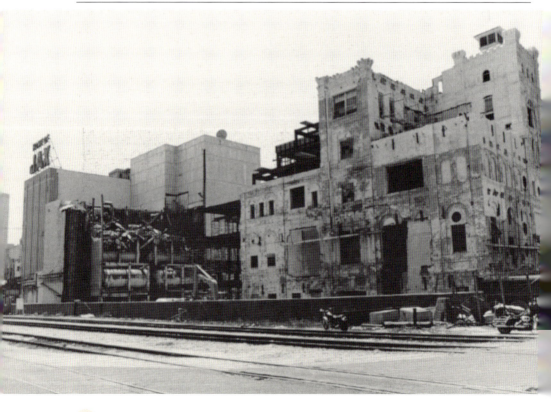

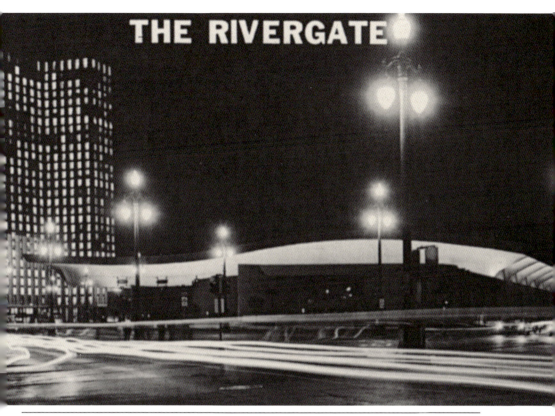

THE RIVERGATE

With a concrete roof that resembled ripples of water, the modern design of the Rivergate Convention Center at the base of Canal Street made it a standout feature of the cityscape's profile. The largest convention space in New Orleans at the time it was built in 1968, the Rivergate hosted events ranging from car shows to Mardi Gras balls. Demolished in 1995, the site is now home to Harrah's Casino. (Past image, originally published by Plastichrome by Colourpicture, PD; present image, Jovannig/Adobe Stock.)

A symbol of the merger of two powerful local trade organizations, the World Trade Center Building was dedicated with much fanfare in 1968. Occupying a footprint that aligns with the cardinal points of a compass, the 33-story tower at the foot of Canal Street was the tallest building in the city at the time of completion. After being closed in 2011, the Four Seasons Hotel group acquired the property and completed a nearly half-billion-dollar renovation, opening its doors in 2021. (Past image, originally published by Grant Morrison, PD; present image, Jovannig/Adobe Stock.)

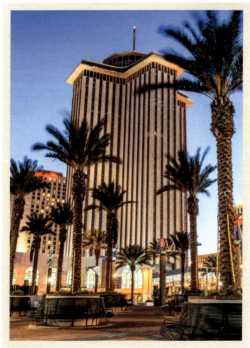

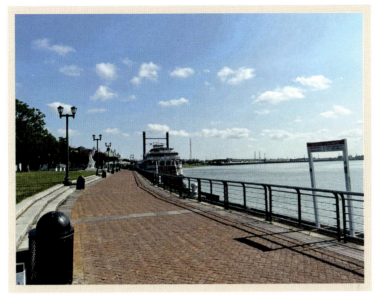

When unused and outdated warehouses and wharves on the riverfront were torn down in the 1980s, it provided an opportunity for the city to create a vantage point from which residents and visitors could enjoy the scenic Mississippi. The result is 16-acre Woldenberg Park, which lies between the Aquarium of the Americas and the Moonwalk across from Jackson Square. Occasionally a live music venue, the park also displays several prominent sculptures along its paved pathways that commemorate Italian immigration and memorialize victims of the Holocaust. (Past image, THNOC.)

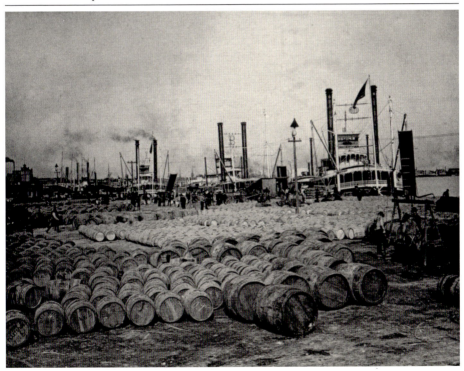

Down by the River

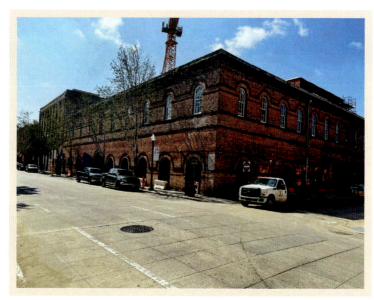

Before its revitalization into a cosmopolitan mix of residences, restaurants, galleries, and shops sparked by the 1984 world's fair, this area was a central point for the storage of goods off-loaded from vessels on the Mississippi River. With development documented back to the 1830s, the narrow streets of the Warehouse District also included presses for natural products and manufacturing facilities. Early warehouse construction was notable for its Greek Revival style, while later buildings reflected an Italian architectural influence. (Past image, the Charles L. Franck Studio Collection, THNOC.)

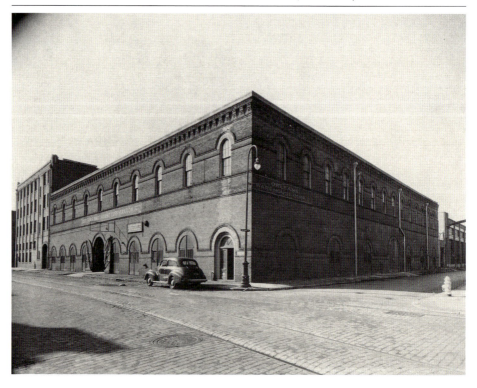

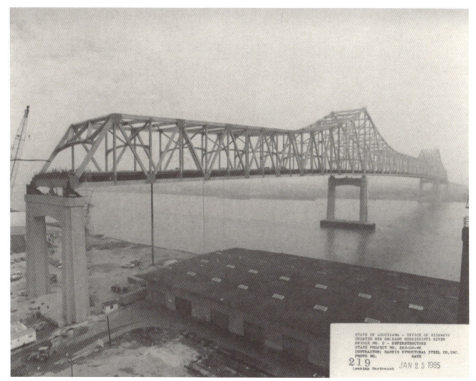

One could refer to it simply by its purpose, which is a bridge over the Mississippi River that extends US Highway 90. Or it can be called the Greater New Orleans Bridge (GNO), the name given to it when the first single cantilevered span was opened in 1958. After a second bridge was added in 1988, however, the structures were collectively referred to as the Crescent City Connection. (Past image, THNOC; present, Kovcs/Adobe Stock.)

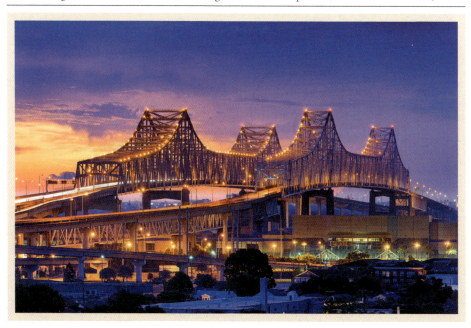

Down by the River

Developed on the former uptown site of the 1884 World's Industrial and Cotton Centennial Exposition, the Audubon Zoo currently encompasses almost 60 acres along the Mississippi River. Much of the zoo's original infrastructure, which was completed in the 1930s by the federal Works Progress Administration, underwent significant renovation and expansion in the 1970s. The zoo is also beloved for its mainstays such as "Monkey Hill," rumored to be the highest point of land in New Orleans. (Past image, the Clarence John Laughlin Archive, THNOC; present image, Audubon Nature Institute.)

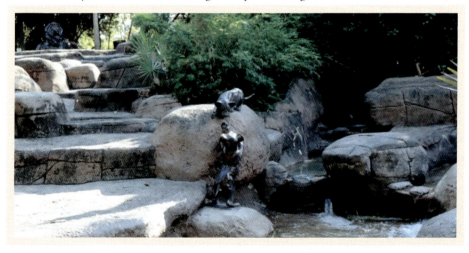

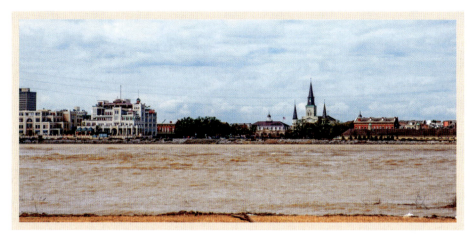

One of the oldest neighborhoods in the city, Algiers is the only portion of New Orleans that is located on the West Bank of the Mississippi River. It is often referred to as "Algiers Point" by river pilots because of the natural angle of the bank carved by the water's flow. A ferry has serviced the area since the 1820s. Aside from a panoramic view of the French Quarter, Algiers is known for its preservation of local culture. (Past image, LOC; present image, William A. Morgan/Adobe Stock.)

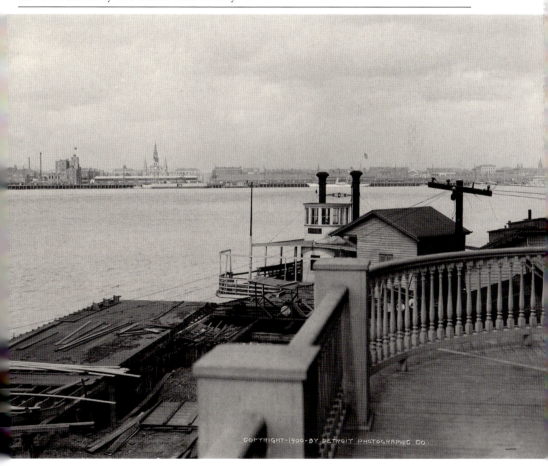

Down by the River

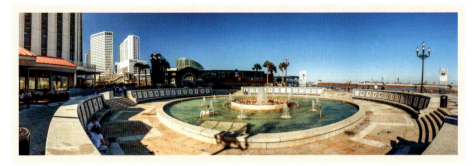

A gift from the European country in 1978 to commemorate a cultural connection, the Spanish Plaza consists of a central fountain surrounded by tile re-creations of every seal of Spain's provinces. Since 1986, the site adjacent to the Riverwalk stores and the Four Seasons Hotel has taken on special significance in the celebration of Lundi Gras, as the place where revelers gather to watch the meeting between carnival royalty—the Kings of Rex and Zulu. (Past image, the Mayor Moon Landrieu Photograph Collection, New Orleans Public Library; present image, Jovannig/Adobe Stock.)

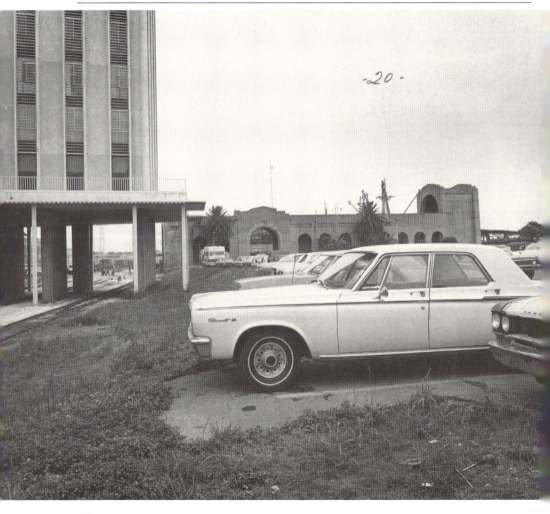

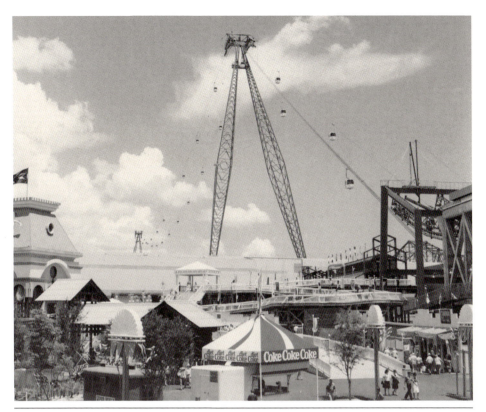

The first commuter gondola lift in the nation, the Mississippi Aerial River Transit (MART) was completed to be used in tandem with the 1984 world's fair. Massive 358-foot-tall steel towers sitting atop piles driven almost 300 feet into the earth supported the cables that were lifted 200 feet above the river. Commuters rode in 53 cars between stations on Julia Street and De Armas Street in Algiers. MART's infrastructure was dismantled in 1994. (Past image, THNOC.)

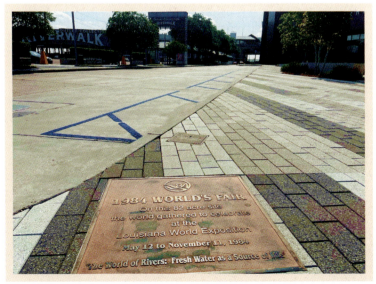

Down by the River

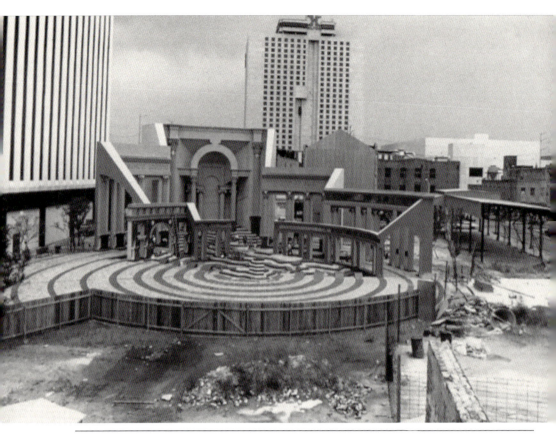

Adjacent to the American Italian Cultural Center, at the corner of Commerce and Lafayette Streets, the Piazza d'Italia is a postmodern homage to a country of origin for many of the city's immigrants. Designed by a former dean of the Yale School of Architecture, Charles Moore, and two local architects, the Piazza d'Italia features a central fountain shaped like the Italian peninsula, surrounded by classical forms crafted from modern materials. The project was completed in 1978. (Past image, THNOC; present image, photograph by Beth Williamson.)

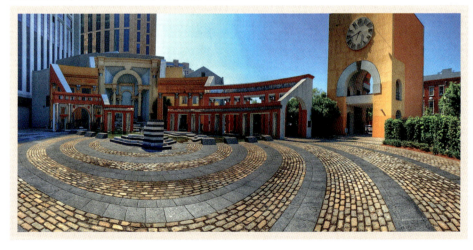

CHAPTER 3

St. Charles Avenue

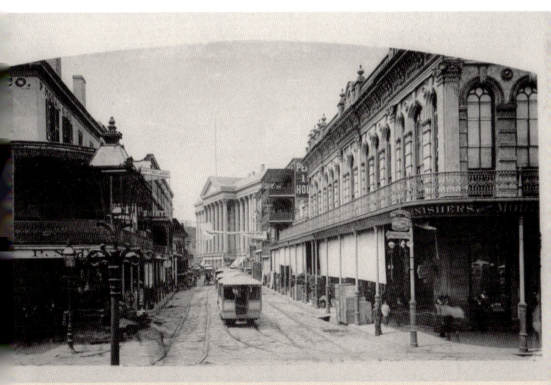

Since 1831, the oldest continuously operating streetcar line in the world, on St. Charles Avenue, has been in service. A more recent line was put along the riverfront between the French Quarter and the Warehouse District. (Past image, THNOC.)

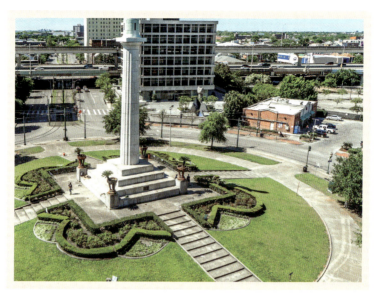

Officially named Place du Tivoli, the traffic circle at the intersection of St. Charles and Howard Avenues is seen as an unofficial nexus of uptown and downtown. An observation point from which one could see some of the unique architecture in the city, such as the Jerusalem Temple building and the Main Public Library, the space became locally known as "Lee Circle," after a column displaying a statue of Robert E. Lee was erected in 1884. (Past image, originally published by Curt Teich and Co., PD; present image, Eric/Adobe Stock.)

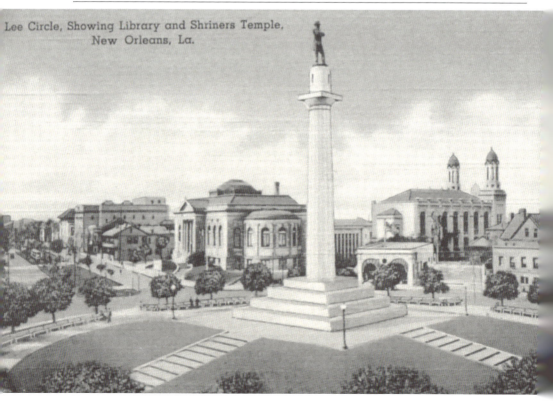

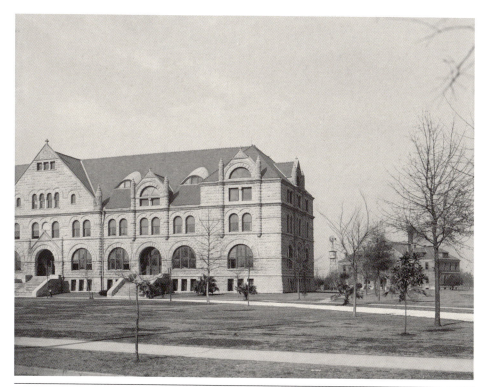

Originally founded in 1834 as one of the first medical schools in the United States, Tulane University of Louisiana then became a public university before an endowment from Paul Tulane in 1884 allowed the school to evolve into the private research institution that it is today. Located uptown, the 110-acre campus features a variety of architectural styles but is perhaps best known for its first building, Gibson Hall, which greets visitors entering from St. Charles Avenue. (Past image, LOC.)

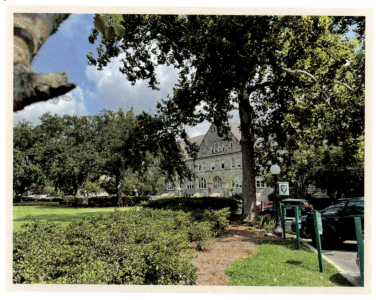

St. Charles Avenue

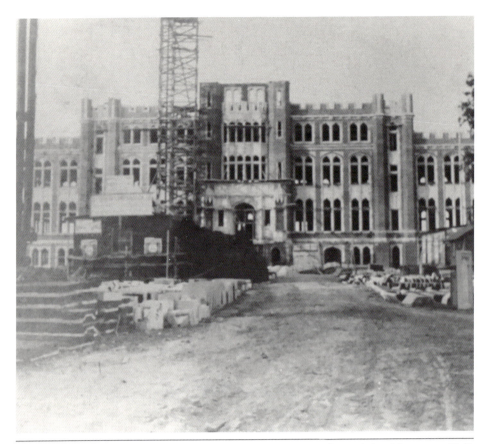

Established in 1904 in an area of uptown acreage purchased by the Society of Jesus in 1884, Loyola University in New Orleans was the culmination of a vision that began in 1847 when seven members of the Jesuit Order arrived in the city. Located on St. Charles Avenue across from Audubon Park, visitors are welcomed by Marquette Hall, the oldest building on campus, and the Holy Name of Jesus Church. (Past image, the Loyola University New Orleans Photographs Collection, Special Collections & Archives, Loyola University New Orleans; present image, Ferrer Photography/Adobe Stock.)

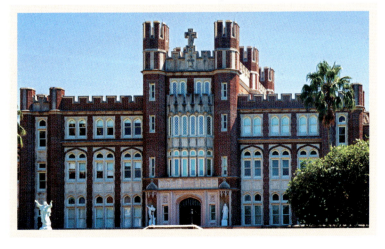

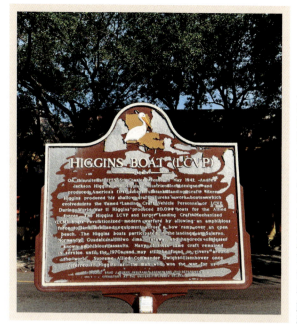

In a conversation between Pres. Dwight Eisenhower and noted historian Stephen Ambrose in 1964, the president referred to local boatbuilder Andrew Higgins as the man who won World War II for the Allies. While Higgins Industries had sites all over south Louisiana, its headquarters was located at 1755 St. Charles Avenue. Higgins is credited with creating the first fully integrated workforce in the city, employing some 20,000 patriotic men and women. (Past image, State Library of Louisiana.)

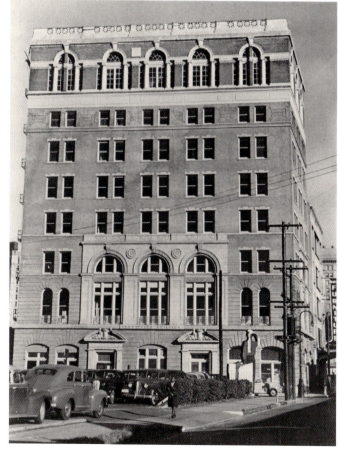

St. Charles Avenue

Named in honor of naturalist and artist John James Audubon, the over 300-acre park is bounded by the Mississippi River and St. Charles Avenue in the uptown area of the city. The land upon which the park sits has been the backdrop of large-scale and significant events such as hosting a world's fair. In the modern era, the park is known for being frequented by Tulane and Loyola students and families visiting the Audubon Zoo. (Past image, LOC; present image, Kristina Blokhin/Adobe Stock.)

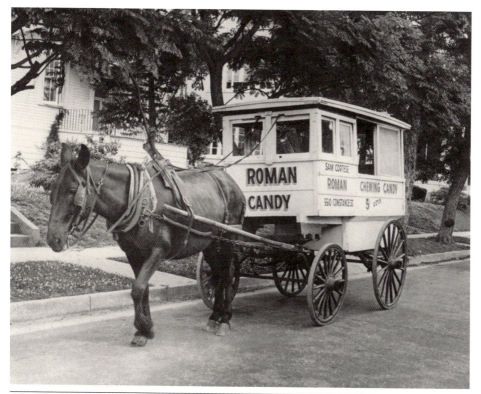

When Italian confectioner Angelina (Napoli) Cortese came to New Orleans from Sicily in the late 1880s, she brought with her an original recipe for candy that she often shared with family and friends. In 1915, Angelina's son Sam worked with local craftsman Tom Brinker to build the first Roman Candy cart, which contained everything necessary to create the taffy and sell it as he rolled through the streets of the city. The family tradition continues today. (Past image, acquisition made possible by the Clarisse Claiborne Grima Fund, the William Russell Jazz Collection at the Historic New Orleans Collection, THNOC; present image, William Morgan/Alamy, Inc.)

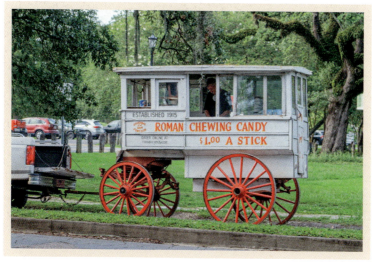

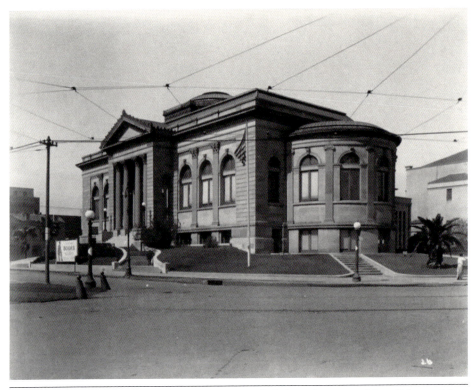

The city's first library was originally housed in the French Quarter before ultimately opening its main library building on Tivoli Circle in 1908. Fueled by generous donations from businessmen like Andrew Carnegie, the library's collections and footprint grew to include branches across New Orleans. Many of these same branches suffered severe damage to their physical plants and contents during Hurricane Katrina. Today, the main library is in a former mansion on St. Charles Avenue. (Past image, THNOC.)

CHAPTER 4

The Business District

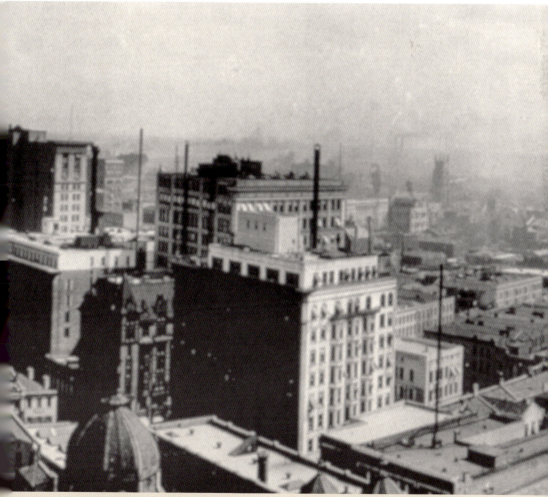

Although the city had already left behind its humble beginnings along the river early in the 20th century, demand by business and government compelled the burgeoning Central Business District to build boldly as the century progressed. (Past image, LOC.)

In 1975, the Superdome became the largest fixed dome structure in the world. Since that time, the space underneath the Lamella-style roof has been the home field of the National Football League's (NFL) New Orleans Saints and the National Basketball Association's New Orleans Jazz and has also hosted storied college football rivalries such as the Bayou Classic and several NFL Super Bowls. During Mardi Gras, "the Dome" becomes a ballroom for Super Krewe Endymion. (Past image, Boh Brothers Construction Co., LLC; present image, Kevin Ruck/Adobe Stock.)

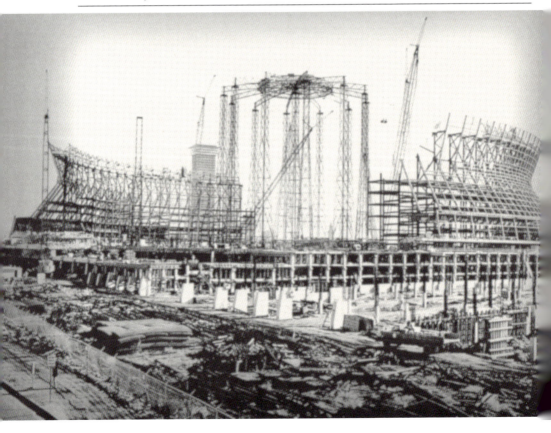

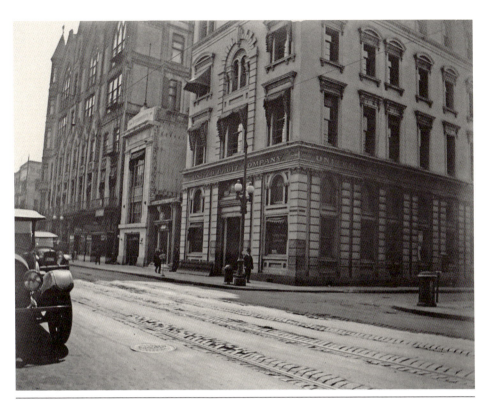

The 10-story building at 321 St. Charles Avenue and Union Street once housed one of the largest fruit import companies in the world. Designed by local architectural firm Diboll and Owen, the 50,000-square-foot space accommodated the consolidation of several United Fruit offices in New Orleans. Constructed in an homage to Spanish style, one of its most distinguishing features that remains today is its terra-cotta sculpture of cornucopias and a fruit basket over the main entryway. (Past image, Waldemar S. Nelson/THNOC; present image, photograph by Beth Williamson.)

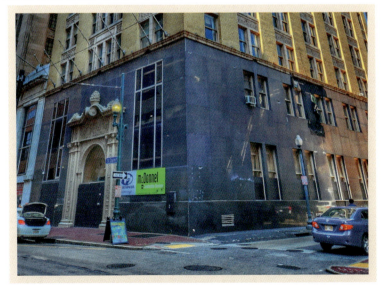

THE BUSINESS DISTRICT

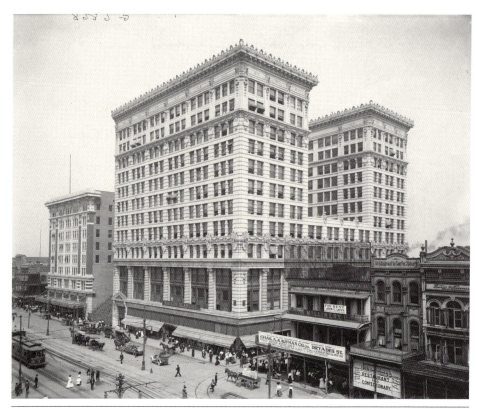

Planned and constructed by local businessman S.J. Schwartz in 1906, Maison Blanche (translated "white house") provided five floors of fine goods for generations of families as one of the city's first department stores, below a section designated for medical offices. After formally closing its doors in 1997, the Canal Street landmark was rescued that same year by the Ritz-Carlton Hotel brand, which opened the repurposed building in 2000. (Past image, LOC; present image, the Ritz-Carlton Hotel Company, LLC.)

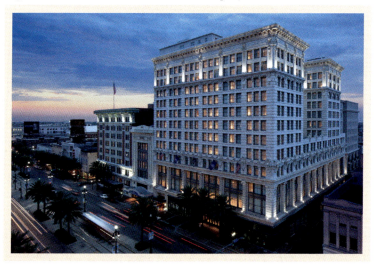

50 THE BUSINESS DISTRICT

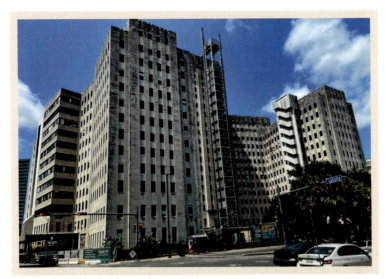

The second-oldest continuously operated public hospital in the United States, Charity Hospital for the Poor was founded in 1736 on the corner of Bienville and Chartres Streets after a bequest from a French shipbuilder. After many relocations across the city, Charity became a cornerstone on Tulane Avenue in 1939 until its closure following Hurricane Katrina in 2005. Vacant since that time, the Art Deco building has drawn its share of proposed innovative redevelopments. (Past image, the Charles L. Franck Studio Collection, THNOC.)

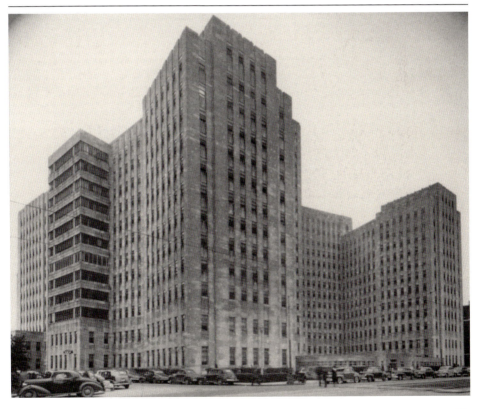

In the days before airlines, many covered long distances by train. In New Orleans, one of the hubs for travel by train from 1908 through 1955 was the Southern Railway Terminal at the corner of Canal and Basin Streets. Designed in the Beaux-Arts style by architect Daniel Burnham, the terminal was consolidated with five others in 1954 at the Union Passenger Terminal on Loyola Avenue before being demolished in 1955. (Past image, LOC.)

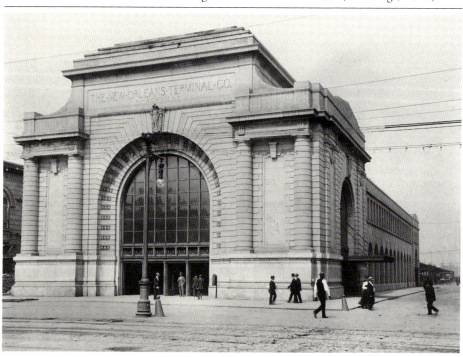

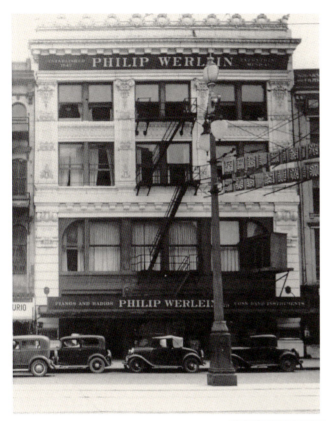

The Werlein's four-story flagship store took its slogan, "Everything Musical," very seriously. The continuation of a business brought to New Orleans in 1854, the building on Canal Street facilitated instrument sale and repair, gave lessons, sold concert tickets, and also housed a sheet music publishing company. An auditorium adorned its top floor. Though the store closed in 2003, the structure found a new identity as the Palace Café, a restaurant operated by the Brennan family. (Past image, the Charles L. Franck Studio Collection, THNOC.)

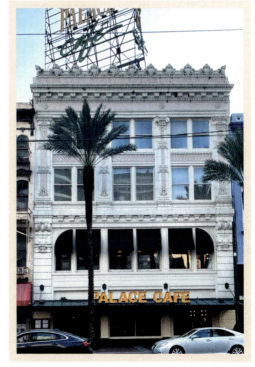

The Business District

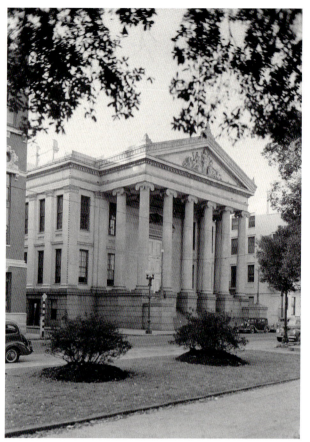

Named after its architect, James Gallier Sr., Gallier Hall is considered to be one of the finest examples of the Greek Revival style in the United States. After construction was completed in 1853 by builder Robert Seaton, the three-story marble structure served as New Orleans's city hall until the 1950s. In modern times, the viewing stand at Gallier Hall is the backdrop for ceremonial toasts to Mardi Gras royalty by city officials. (Past image, LOC.)

The second-oldest park in the city, Lafayette Square is named after Gilbert du Motier, the Marquis de LaFayette, who served as a general in the American Revolution. First rising to quiet prominence because of its proximity to Gallier Hall, Lafayette Square now finds itself surrounded by the bustling Central Business District and the federal court building. Today, it is known for an annual concert series and festivals. (Past image, THNOC.)

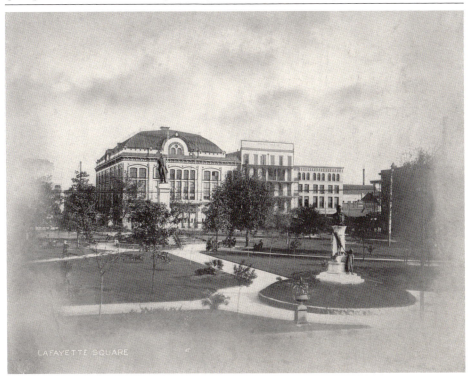

THE BUSINESS DISTRICT

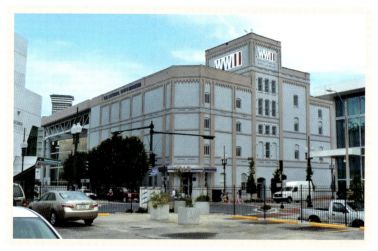

Built on the former site of the Weckerling Brewery between Camp and Magazine Streets, what began as an effort by noted historian and local resident Stephen Ambrose to commemorate the city's contribution to D-Day is now dedicated to the entirety of the nation's efforts during World War II. After opening on June 6, 2000, the Smithsonian-affiliated museum has continued to grow significantly and to wide acclaim and has also resulted in an aesthetic change to the city's skyline. (Past image, THNOC; present image, the National WWII Museum.)

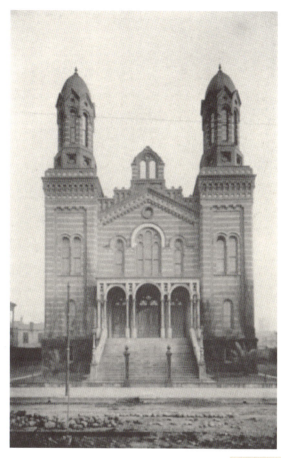

The former temple of Louisiana's largest Jewish congregation was originally completed in 1872 on Carondelet Street. With Romanesque-Byzantine design and adorned with two towers over 100 feet in height, Temple Sinai was said to have made a unique architectural statement in the city among other places of worship. After the congregation moved to a new temple in the 1920s, the building was sold to the Knights of Pythias and ultimately demolished in 1977. (Past image, THNOC.)

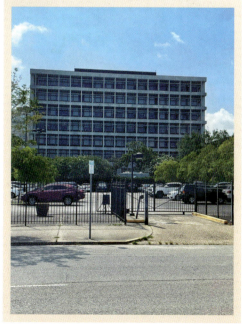

Once the tallest tower in the city's skyline since 1921, the 23-story Renaissance-style Hibernia Building at the corner of Gravier and Carondelet Streets is perhaps best recognizable for what sits atop it. The white cupola functioned as a beacon for ships on the Mississippi and served as a reminder of the holiday spirit, with different colorful light combinations adorning the structure for Christmas and Mardi Gras. (Past image, Eleanor G. Burke, THNOC; present image, SeanPavonePhoto/Adobe Stock.)

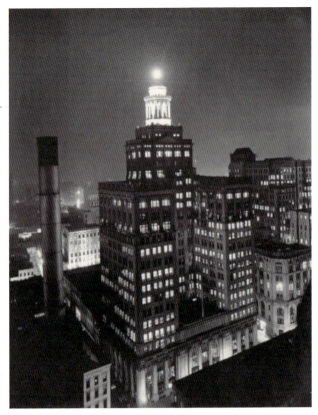

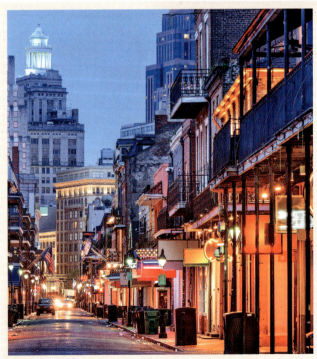

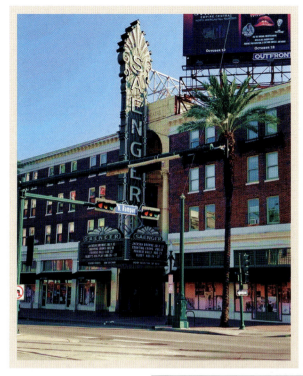

Known for its unique interior that was designed to capture the beauty of an Italian Renaissance courtyard beneath a starry evening sky, the Saenger Theater on Canal Street has been one of the city's premiere entertainment venues since 1927. A home for many genres of live performing arts, it also functioned as a magnificent movie theater under the Paramount banner. After sustaining significant damage in Hurricane Katrina, the venue was restored to its former elegance in 2013. (Past image, the Charles L. Franck Studio Collection, THNOC.)

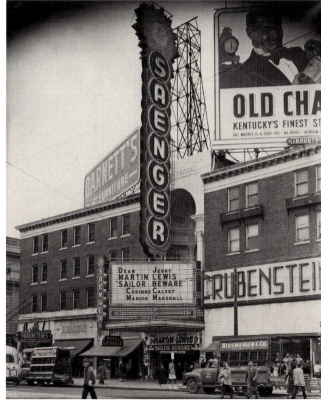

THE BUSINESS DISTRICT

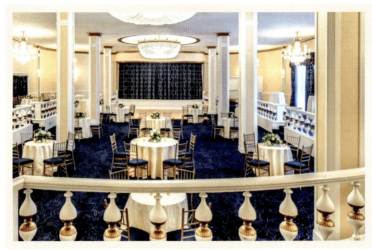

Aside from its world-famous Sazerac Bar, the Roosevelt Hotel on Canal Street also lays claim to one of the premiere event and entertainment venues of the last century. Upon its opening on December 31, 1935, the Blue Room had a reputation for elegance and style, hosting big bands in the 1940s as well as entertainers in the stratosphere of Frank Sinatra, Louis Armstrong, and Ella Fitzgerald. Although the Blue Room closed in 1989, the space is still popular for private events. (Past image, originally published by the Roosevelt Hotel, PD; present image, the Waldorf Astoria.)

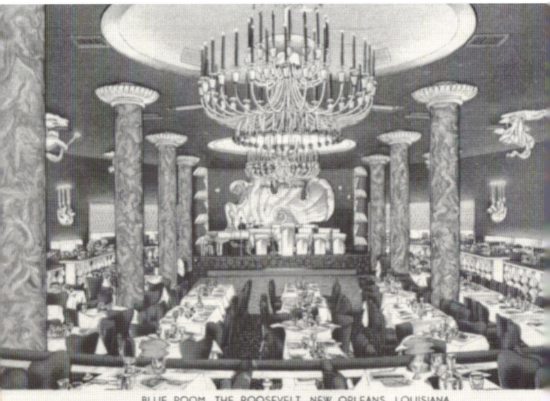

60 THE BUSINESS DISTRICT

CHAPTER 5

NOLA's Neighborhood Flavor

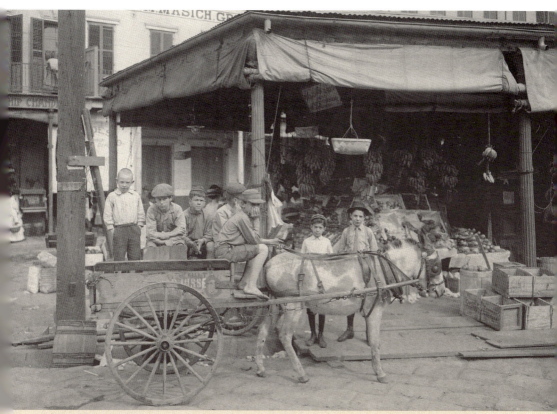

What ingredients help distinguish one NOLA neighborhood flavor from the next? One part is the sense of community created by hubs such as churches, restaurants, and markets. Other factors include natural features and local celebrations. (Past image, acquisition made possible by the Clarisse Claiborne Grima Fund, the William Russell Jazz Collection at the Historic New Orleans Collection, THNOC.)

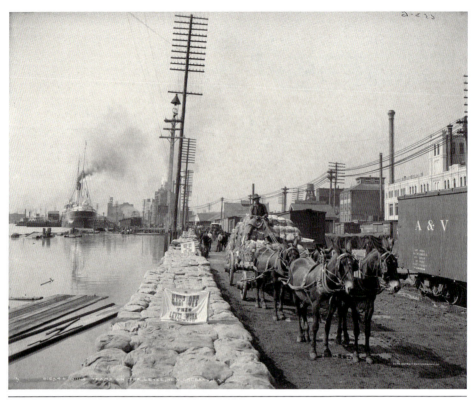

Although the oldest part of New Orleans sits atop the high ground of a natural levee, the rest of the area is not as fortunate. Though their complexity has changed since first being used in 1717, history has shown that the wrath of Mother Nature will not be contained by man-made levees. After the levee system failed during Hurricane Katrina, it is estimated that 80 percent of the city was flooded up to a depth of 20 feet. (Past image, LOC; present image, photograph by Infrogmation of New Orleans.)

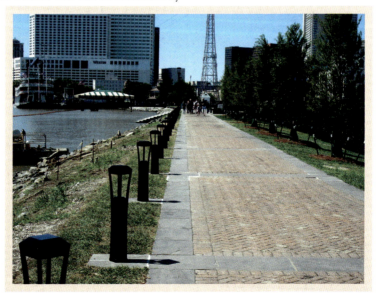

62 NOLA's Neighborhood Flavor

What began in the 1950s as an art gallery space on St. Peter Street where local musicians would rehearse was formally established in 1961 to become a repository to record the city's rich cultural resource of traditional jazz music. Now operated by the nonprofit Preservation Hall Foundation, the venue features a house band and concerts 360 nights a year and provides for the future of jazz by hosting workshops, lessons for children, and sponsoring a Junior Jazz Band. (Past image, THNOC; present image, photograph by Beth Williamson.)

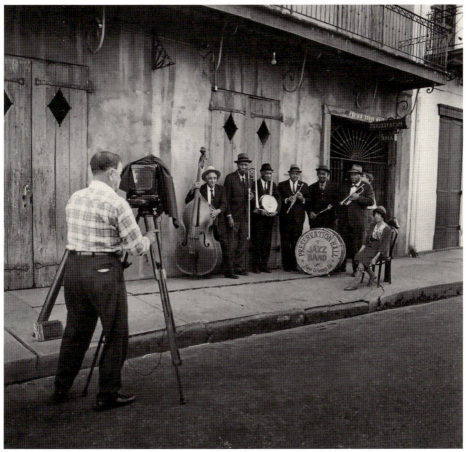

NOLA's Neighborhood Flavor

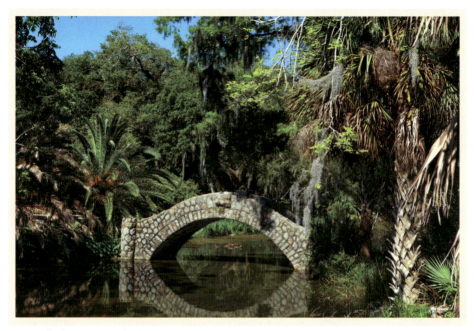

Originally known as a dueling ground in the early 19th century, City Park grew along Bayou Metairie and was formally recognized by the city in 1854. Today, it boasts approximately 1,300 acres, which contain amenities such as a carousel and Storyland amusement park, Tad Gormley Stadium, the New Orleans Museum of Art, and a botanical garden. (Past image, LOC; present image, jimbowie/Adobe Stock.)

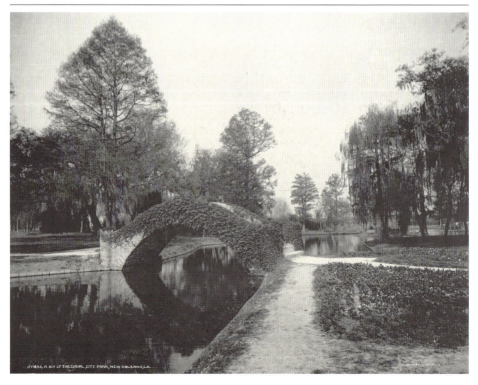

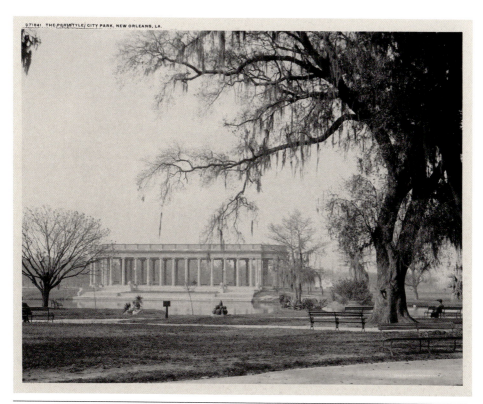

A favorite setting for local photographers, the Neoclassical pavilion in City Park was designed by architect Paul Andry and built in 1907. Known at that time as the Paristyleum, the structure was designed as a dance floor to be used in conjunction with evening concerts at an adjacent bandstand. (Past image, LOC.)

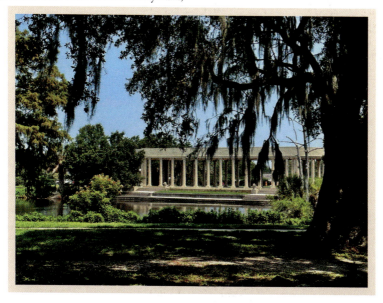

NOLA's Neighborhood Flavor 65

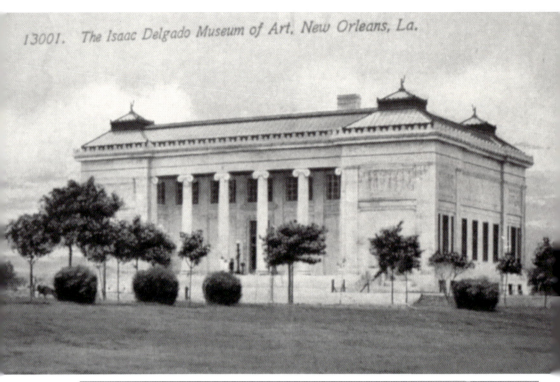

13001. The Isaac Delgado Museum of Art, New Orleans, La.

The New Orleans Museum of Art in City Park opened in 1911 by virtue of a grant from local businessman Isaac Delgado. Since then, the museum has grown with the addition of the Wisner Education Wing in the 1970s, another major expansion and renovation in the 1990s, and, more recently, the creation of the Sydney and Walda Besthoff Sculpture Garden. The museum's permanent collection contains exhibits from the Italian Renaissance through Impressionism and into the modern era. (Past image, PD postcard originally published by the Acmegraph Co.)

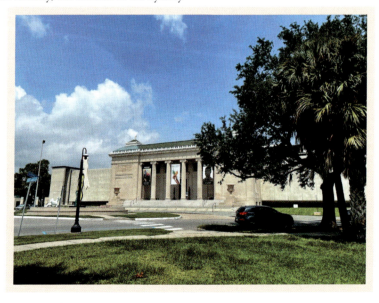

The remaining sliver in mid-city of what was once a natural system of drainage for the land upon which New Orleans was built, once served as a waterway navigated regularly by Native Americans. Early European settlers similarly used Bayou St. John and its tributaries as a route for trade, culminating in the establishment of a fort in 1701. Over time, the body of water was shaped and constrained by roads, newly dug canals, and dredging. (Past image, Samuel Wilson Jr., THNOC.)

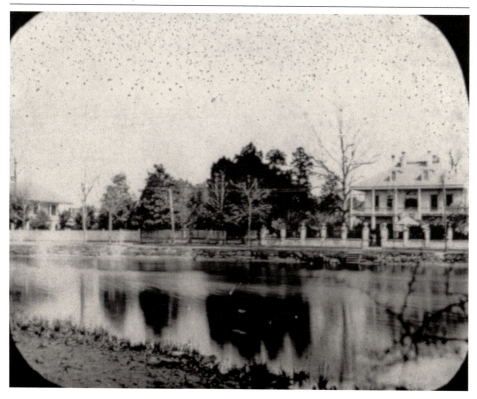

NOLA's Neighborhood Flavor

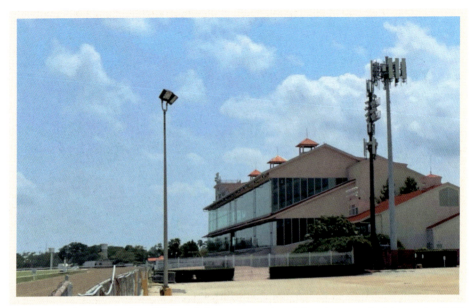

Before it became the New Orleans Fairgrounds, the second-oldest horse racing course still in operation in the United States went by names including Louisiana Race Course and the Creole Race Course. The Crescent City Jockey Club was founded in 1892, long before horse racing became sanctioned by the state legislature in 1940. The grandstand aside the one-mile track has twice been rebuilt after fires, in 1919 and 1993. Today, the fairgrounds hosts the New Orleans Jazz and Heritage Festival. (Past image, the L. Kemper and Leila Moore Williams Founders Collection, THNOC.)

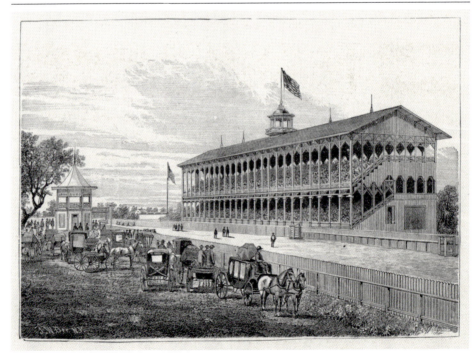

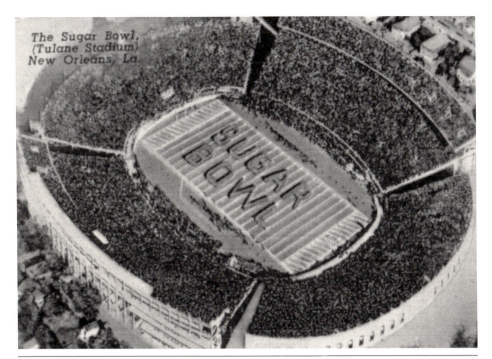

Before the Superdome, Tulane Stadium was where New Orleanians went to enjoy football. From the time of its completion in 1926 until its demolition in 1980, the outdoor venue was the backdrop for college rivalries that included the annual Sugar Bowl and became the first home field of the NFL's New Orleans Saints from 1967 through 1974. Notably, it would also host three Super Bowls, in 1970, 1972, and in 1975. The new Yulman Stadium opened in 2014. (Past image, LOC; present image, Jackson Hill/Tulane University.)

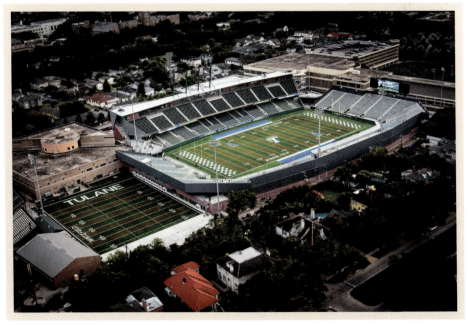

NOLA's Neighborhood Flavor

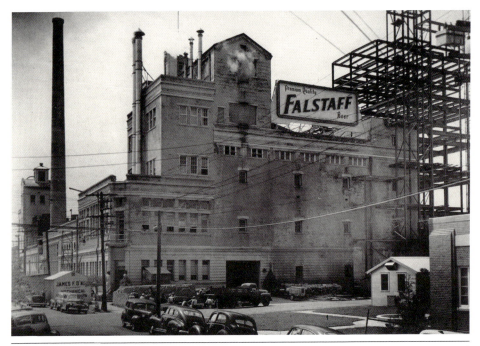

The Falstaff brand purchased the site of its New Orleans brewery in 1936. Located on Gravier Street, the building itself served as a source of weather information with its lighted "weatherball," which changed colors to indicate cloud cover and approaching storms. The shuttered brewery was purchased in 2006 and redeveloped into apartments. Falstaff's iconic neon sign was later recreated and installed as a nostalgic reminder of the building's past. (Past image, City Archives and Special Collections, New Orleans Public Library.)

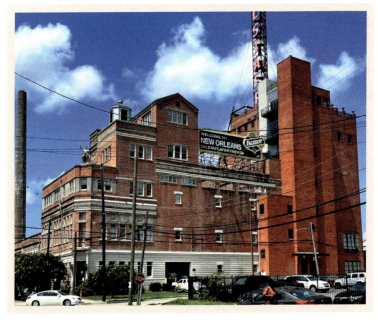

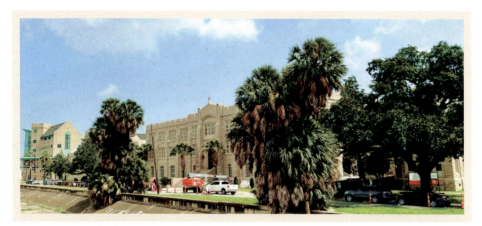

Xavier University's deep ties to Catholicism have produced two distinctions: as the only historically black, private Catholic university in the city and abroad and its founding by a saint. Originally a high school, Xavier transformed upon the launch of the College of Liberal Arts and Sciences in 1925. Although referred to as "the Emerald City" because of the distinct green rooftops, its Gothic Revival–style main building on Palmetto Street remains a crown jewel of the campus. (Past image, the Charles L. Franck Studio Collection, THNOC.)

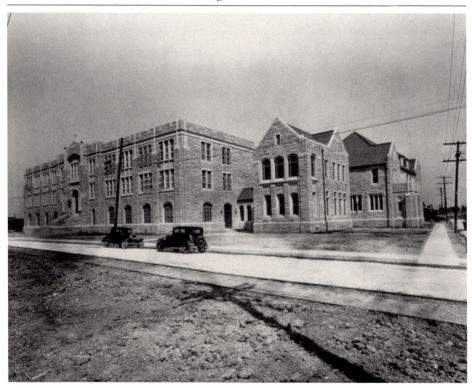

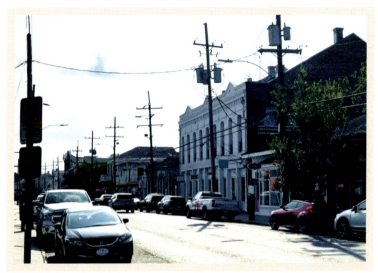

Originally planned during the Spanish colonial period as Calle de Almazen, Magazine Street extends from the city's Central Business District through uptown. Commercial development along the six-mile stretch that follows the curve of the Mississippi River can be traced back to four distinct locations that served as former marketplaces. Today, the thoroughfare is noted for a diverse mix of elements that make up its landscape, which include antique stores, boutiques, art galleries, bars, and restaurants. (Past image, the Charles L. Franck Studio Collection, THNOC.)

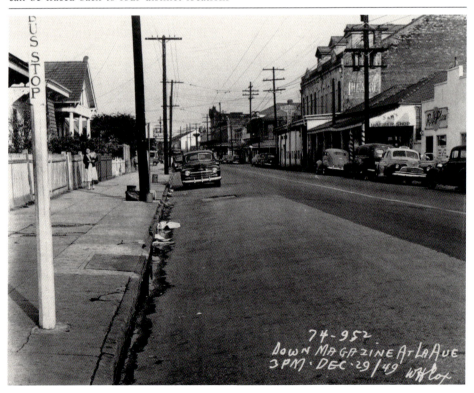

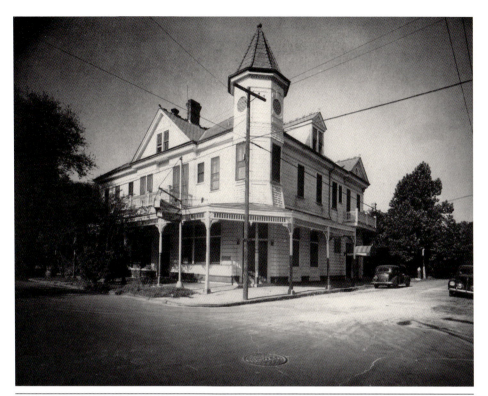

Once known as Lafayette, the area bounded by St. Charles Avenue, Magazine Street, First Street, and Toledano Street developed in the 1830s as large parcels of land upon which the city's wealthy built elegant homes and lush gardens. Today, the area is considered to be one of the best-preserved array of Southern mansions in existence. Visitors to the Garden District will find a unique blend of neighborhood shops and restaurants, including the world-famous Commander's Palace. (Past image, the Charles L. Franck Studio Collection, THNOC; present image, Commander's Palace.)

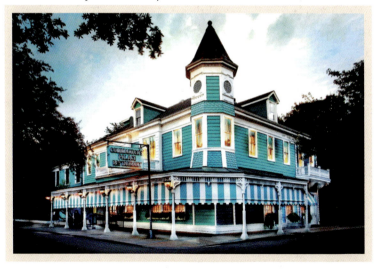

NOLA's Neighborhood Flavor

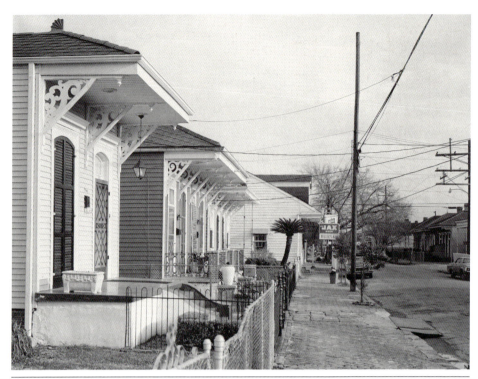

Although the name implies differently, the Irish Channel was also home to African Americans as well as immigrants from Italy and Germany. Bounded by the Mississippi River, Magazine Street, Jackson Avenue, and Delachaise Street, the neighborhood became shaped by a laboring class, a common cultural identity, and a Roman Catholic faith. From an architectural standpoint, the neighborhood is known for its shotgun houses, which are cottage-style dwellings on narrow lots. (Past image, LOC.)

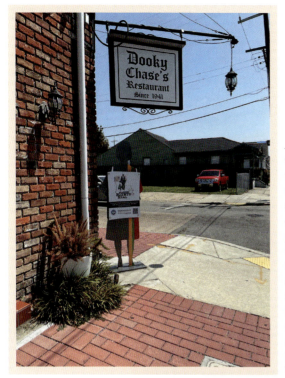

One cannot recount the history of this landmark on Orleans Avenue in the Sixth Ward without also talking about the story of its cofounder and chef, Leah Chase. While its kitchen provided space for the "Queen of Creole Cuisine" to create her world-renowned dishes, Dooky Chase's also holds historical and cultural significance as well. In the 1960s, it was a meeting place of national civil rights leaders and functioned as an African American art gallery. (Past image, John J. Uhl, Porche West, THNOC.)

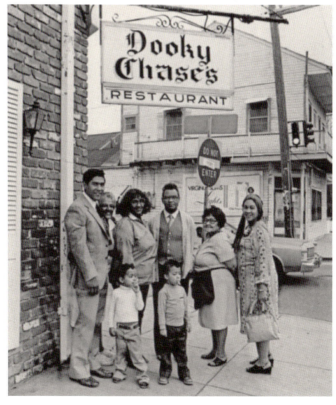

NOLA's Neighborhood Flavor

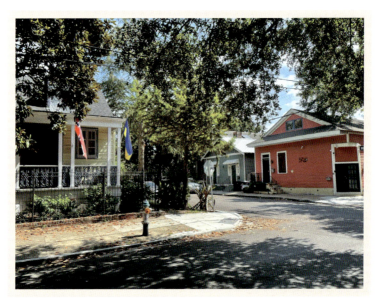

The Faubourg Marigny neighborhood bears the name of its previous landowner, Bernard de Marigny, who subdivided his property in 1806. Development in the area was spurred by the completion of Elysian Fields Avenue, which also accommodated the tracks of the Pontchartrain Railroad. Notable for its Creole-style cottages and residents such as jazz musician Jelly Roll Morton, today the community is celebrated for its art, music, and culinary venues. (Past image, the Charles L. Franck Studio Collection, THNOC.)

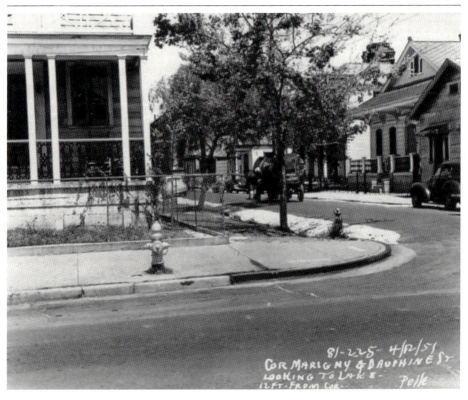

Before Bourbon Street, Basin Street held the distinction of being the city's adult entertainment venue in the late 19th and early 20th centuries. Its construction followed the turning basin of the Carondelet Canal, just outside the boundary of the French Quarter. Formerly a wealthy neighborhood, Basin Street transformed into the red-light district known as Storyville. Much of Storyville's Basin Street footprint was replaced with the Iberville Projects; only a handful of the original buildings remain today. (Past image, acquisition made possible by the Clarisse Claiborne Grima Fund, the William Russell Jazz Collection at the Historic New Orleans Collection, THNOC.)

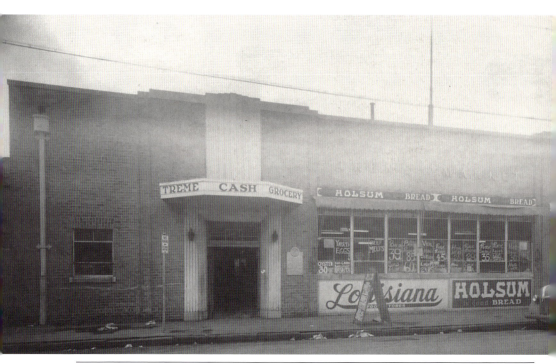

Once known as the "Back of Town," the neighborhood of Tremé is located on the former Morand Plantation where, beginning in the early 1800s, "free persons of color" came together to form a community. Centered around Congo Square, other well-known past landmarks in the vicinity were a former parish prison and the Lafitte Housing Development. Tremé is currently a deserving home to the New Orleans Jazz National Historical Park, considering its number of resident musicians. (Past image, the Charles L. Franck Studio Collection, THNOC; present image, photograph by Beth Williamson.)

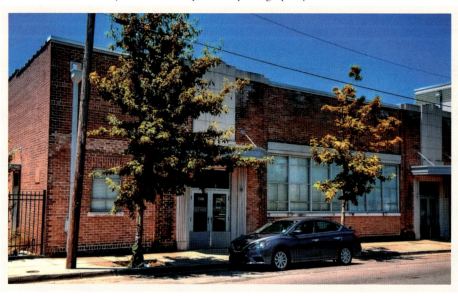

Notable, among many things, for being a location that greatly influenced the development of jazz music in the city, Congo Square also has historical significance as a legal gathering place for enslaved persons from colonial times through the region's antebellum period. Situated in the neighborhood of Tremé, the area was renamed by the city as Armstrong Park in the 1960s and later became the original location of the New Orleans Jazz and Heritage Festival in the 1970s. (Past image, acquisition made possible by the Clarisse Claiborne Grima Fund, the William Russell Jazz Collection at the Historic New Orleans Collection, THNOC; present image, s.k.p./Adobe Stock.)

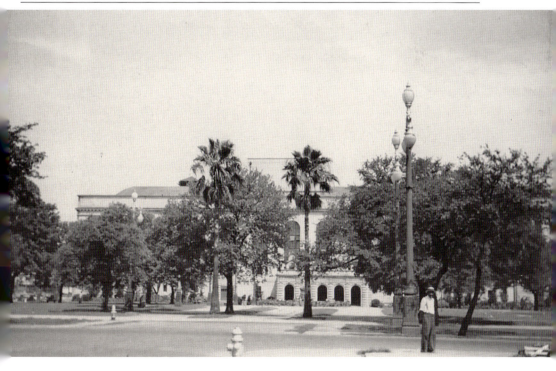

NOLA's Neighborhood Flavor

79

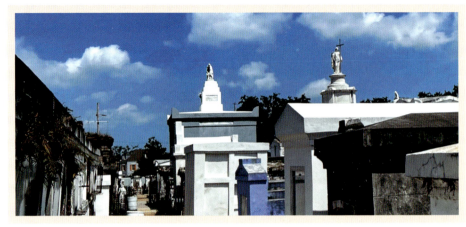

The prominent force behind the cemeteries of New Orleans and the way they are constructed is simple necessity: the land's high water table. A respectful stroll through any of the 42 "cities of the dead" tells stories of various cultural influences and the affluence of those laid to rest there. The aboveground tombs are known for their ornate architectural detail, choice of building material, and adorning statuary. (Past image, State Library of Louisiana.)

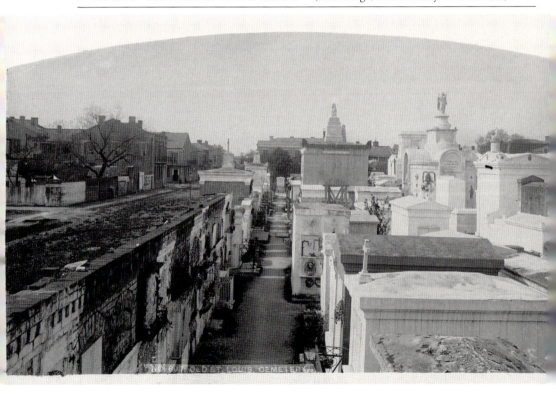

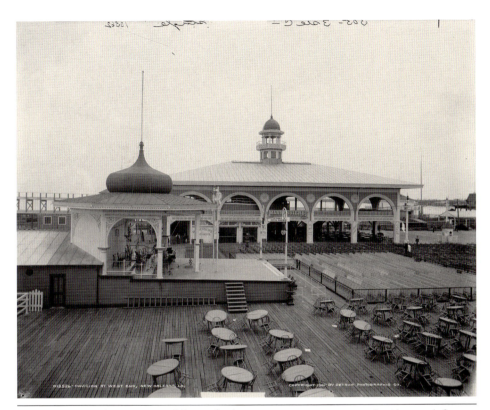

"West End" describes a section of the city built along Lake Pontchartrain around a resort that, among other attractions, collectively earned the name "the Coney Island of New Orleans." In its heyday, West End was a destination for cuisine, amusement park rides, and fun on the water. The city's third-oldest restaurant, Bruning's, had a dining room there that extended over the water. (Past image, LOC.)

NOLA's Neighborhood Flavor

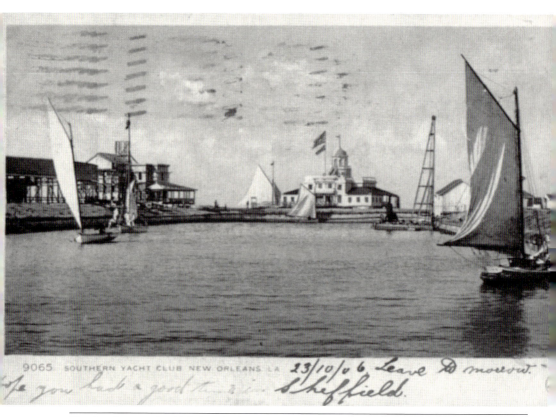

The Southern Yacht Club (SYC), the second-oldest organization of its kind in the United States, dropped anchor in the waters of Lake Pontchartrain in 1878. The year 1879 saw the construction of SYC's first clubhouse, which sat atop pylons in the lake bed. Part of the West End district, SYC hosted its share of formal social events and nautical gatherings. Near the turn of the last century, the club moved to its current location near the Municipal Yacht Harbor. (Past image, published by the Detroit Photographic Company, PD.)

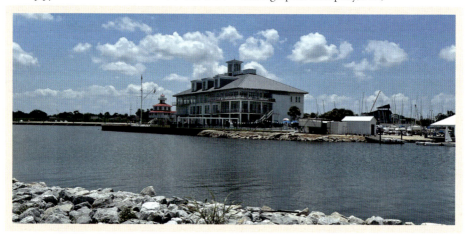

The former expanse of swampland along Lake Pontchartrain was most recognized early on for its West End hotels and entertainment venues. A building boom took place there after World War II, resulting in the construction of small homes. Today, the area boasts amenities for those who enjoy boating and is also home to two parks. (Past image, National Archives and Records Administration, [NAID] 23940517.)

NOLA's Neighborhood Flavor

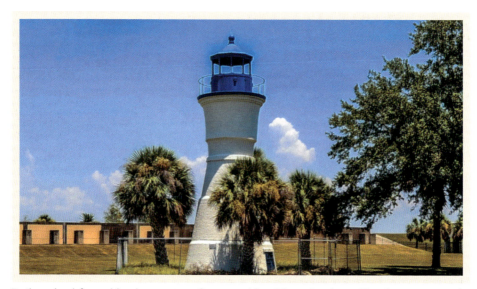

Built on land formed by the creation of a new seawall and lake bed fill, Pontchartrain Beach provided fun for generations of thrill seekers. Owned and operated by the Batt family, it was known for an assortment of rides, which included the Ragin' Cajun and the Zephyr. The venue also hosted concerts for performers like Elvis Presley. Closed in 1983, the footprint of "the beach" is currently occupied by the University of New Orleans' Research & Technology Park. (Past image, published by Pontchartrain Beach, PD; present image, photograph by Beth Williamson.)

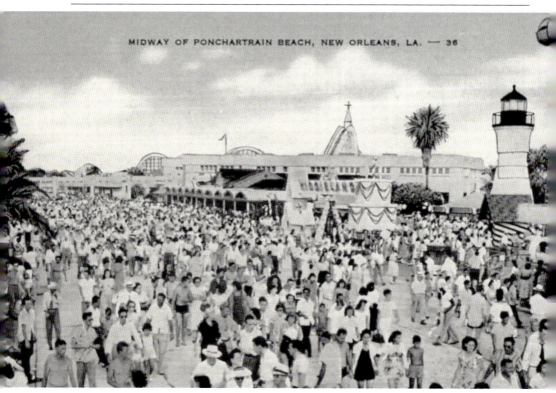

NOLA's Neighborhood Flavor

When the movement for a public university in the city took root in the 1950s, an answer was found at a former naval air station on Lake Pontchartrain. Opening in 1958, the Louisiana State University in New Orleans (LSUNO) became the first public university in the South that was racially integrated. In 1974, the name of the school changed to reflect its unique identity, becoming the University of New Orleans (UNO). The university boasts over 80,000 alumni. (Past image, courtesy of the University of New Orleans.)

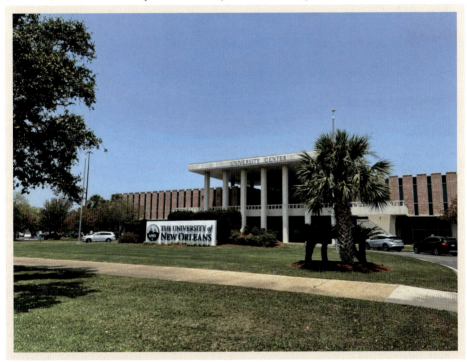

NOLA's Neighborhood Flavor

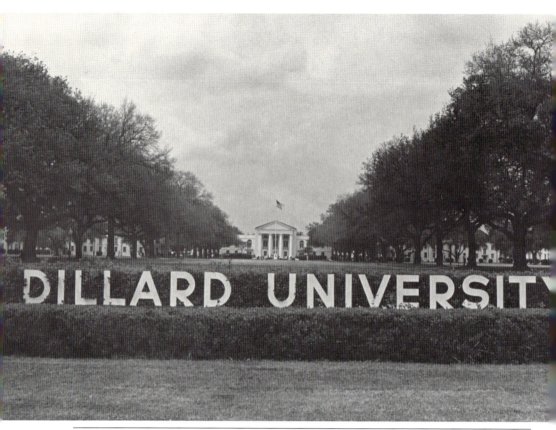

This historic African American university can trace its origins back to two schools of high learning that developed after the Civil War: Straight College and Union Normal School. Named after a Virginia educator, James H. Dillard, the university formally started classes in 1935, though it was chartered in 1930. Today, the over 50-acre campus in the city's Seventh Ward offers 22 majors to its students. Rosenwald Hall greets visitors from Gentilly Boulevard. (Past image, courtesy of the New Orleans Jazz Club Collection, Louisiana State Museum/New Orleans Jazz Museum.)

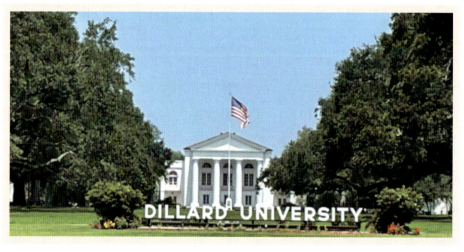

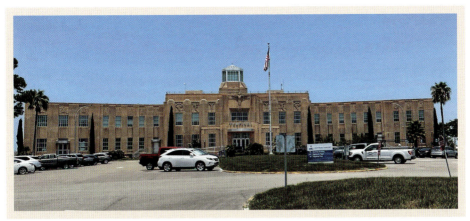

Famed Louisiana governor Huey Long launched construction of the Art Deco gem in 1929 that formerly served as the official airport of the New Orleans metropolitan area. Built on the shore of Lake Pontchartrain atop artificially reclaimed land, when completed in 1934, the airport bore the name of local levee board president Abraham Shushan. In 1946, operations at the small terminal were transferred to what is now known as Louis Armstrong New Orleans International Airport. (Past image, the Charles L. Franck Studio Collection, THNOC.)

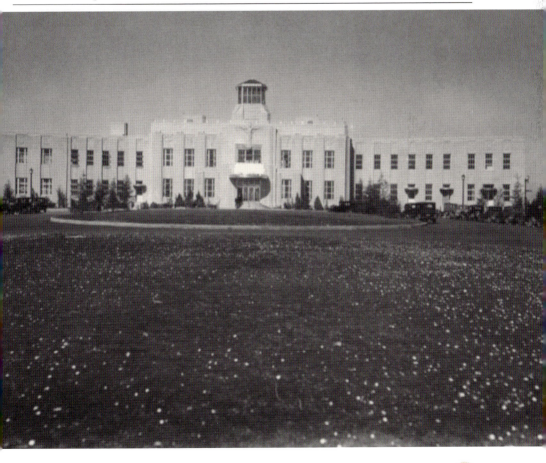

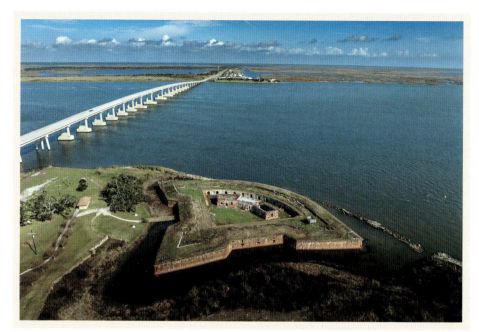

Across the Industrial Canal, New Orleans East can trace its history of development back to two military installations, including Fort Pike; a lighthouse; and a sugar refinery along Lake Catherine in the early 1800s. In the 1950s, the area saw the construction of suburban-style neighborhoods and shopping destinations typical of that era. Within its boundaries today visitors can also find the Bayou Sauvage National Wildlife Refuge, which is the largest of its kind in an urban area. (Past image, published by A. Hirchwitz, PD; present image, Tamas/Adobe Stock.)

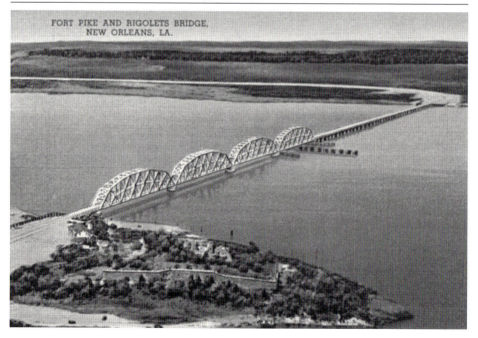

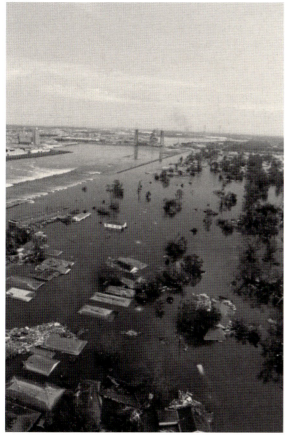

The "lower" in this area's name refers to its proximity to the mouth of the Mississippi River; "Ninth Ward" is a term for voting district. Following Hurricane Katrina, loss was felt more deeply in the tight-knit intergenerational neighborhoods of the city, such as this one. Over 70 percent of all occupied units in the city sustained damage related to the storm and levee failures. Residents here have shown resilience in rebuilding their homes, community businesses, and lives with patience and determination. (Past image, FEMA/Jocelyn Augustino; present image, timrobertsaerial/Dreamstime.)

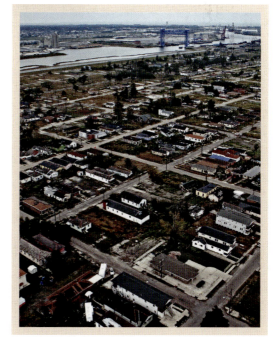

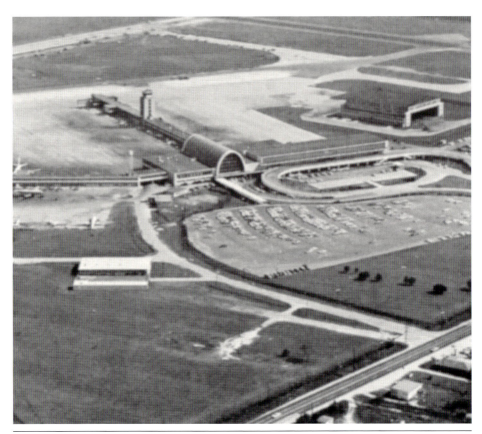

On January 13, 1946, French-Canadian aviator daredevil John Bevins Moisant lent his name to the city's new airport, which is located on land in neighboring Jefferson Parish. In 2001, on the occasion of the 100th anniversary of the birth of New Orleans's beloved musician Louis Armstrong, the airport was renamed in his honor. The original terminal was decommissioned after the completion of a new physical plant in 2019 for an estimated cost of $1.3 billion. (Past image, *Jefferson Yearly Review*; present image, New Orleans International Airport.)

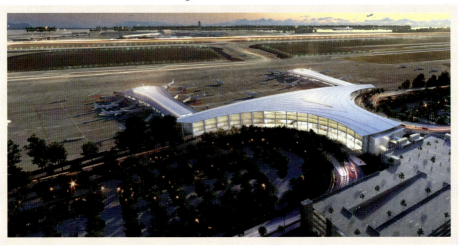

CHAPTER 6

Mardi Gras Memories

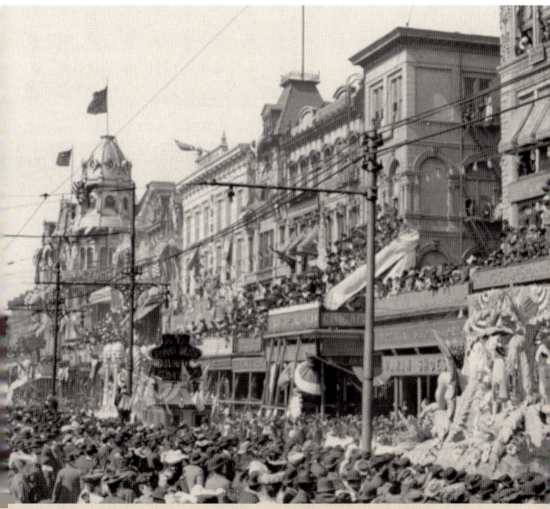

Part religious observance, part celebration, Mardi Gras is the purple, green, and gold gift that New Orleans gives to the world. For one day, people from all walks of life stand shoulder to shoulder and just enjoy a parade together. (Past image, LOC.)

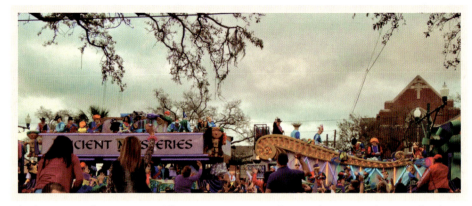

The first reported appearance of floats in New Orleans Mardi Gras was in association with the Mistick Krewe of Comus in 1857. Today, the crafting of these parade centerpieces is a celebrated art form. Professional float builders work all year in "dens" to produce sometimes dozens of vehicles for a single parade, which typically revolves around a single theme. Two recent developments are the creation of Endymion's "superfloats" and "housefloats" made popular during the COVID epidemic. (Past image, LOC; present image, photograph by Bart Everson.)

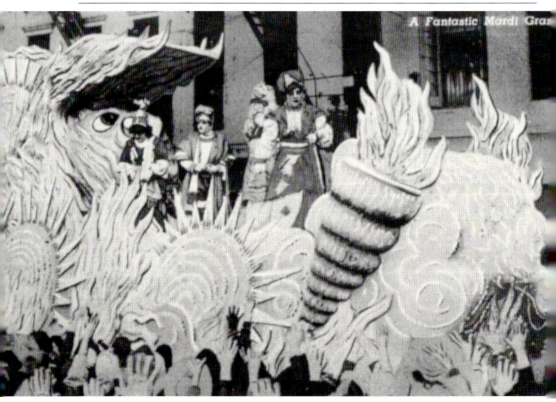

Local lore provides that the Krewe of Zulu was organized in 1909 after its founding members watched a comedy skit about the African tribe. It is suggested that the first resulting parade was likely a combination of area clubs and benevolent societies. William Story served as Zulu's first king and wore a tin can crown while holding a banana stalk scepter, parodying other carnival royalty. The Krewe is known for handing out decorated coconuts from its floats. (Past image, acquisition made possible by the Clarisse Claiborne Grima Fund, the William Russell Jazz Collection at the Historic New Orleans Collection, THNOC; present image, Ninette Maumus/Alamy, Inc.)

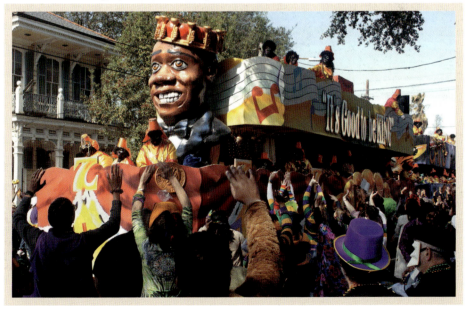

MARDI GRAS MEMORIES 93

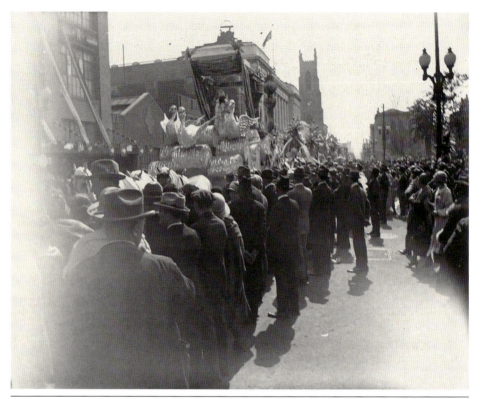

In the minds of many New Orleanians, the Krewe of Rex heralds an official winding down of the Mardi Gras season. To that end, when the parade approaches its last leg of Canal Street, the appearance of the King of Rex draws one last burst of fanfare from weary revelers. (Past image, a gift of Waldemar S. Nelson, THNOC; present image, Carol M. Highsmith's America, Prints and Photographs Division, LOC.)

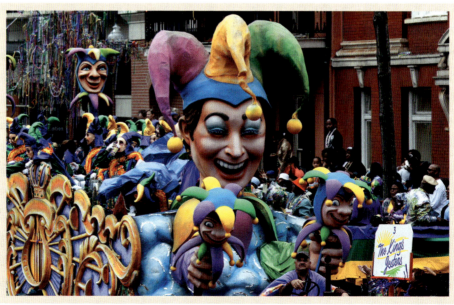

MARDI GRAS MEMORIES

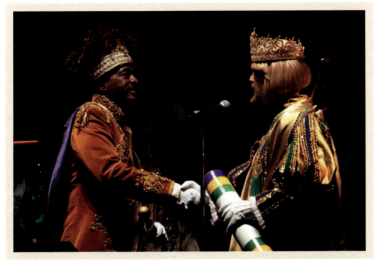

The "Fat Monday" before Fat Tuesday has been celebrated in various ways since 1874, when the King of Rex first entered the city by steamboat before heading to Gallier Hall. More recently, the occasion has been branded as Lundi Gras, a series of events along the riverfront, including the ceremonial handing over of New Orleans to the King of Zulu and the King of Rex by the mayor at Spanish Plaza. (Past image, LOC; present image, photograph by Brendan Mullin/US Department of Defense.)

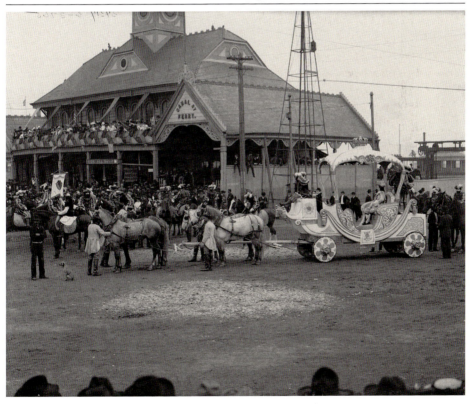

Mardi Gras Memories

Discover Thousands of Local History Books Featuring Millions of Vintage Images

Arcadia Publishing, the leading local history publisher in the United States, is committed to making history accessible and meaningful through publishing books that celebrate and preserve the heritage of America's people and places.

Find more books like this at
www.arcadiapublishing.com

Search for your hometown history, your old stomping grounds, and even your favorite sports team.

Consistent with our mission to preserve history on a local level, this book was printed in South Carolina on American-made paper and manufactured entirely in the United States. Products carrying the accredited Forest Stewardship Council (FSC) label are printed on 100 percent FSC-certified paper.